THE PERFECT
PORTFOLIO

THE PERFECT PORTFOLIO

BY HENRIETTA BRACKMAN

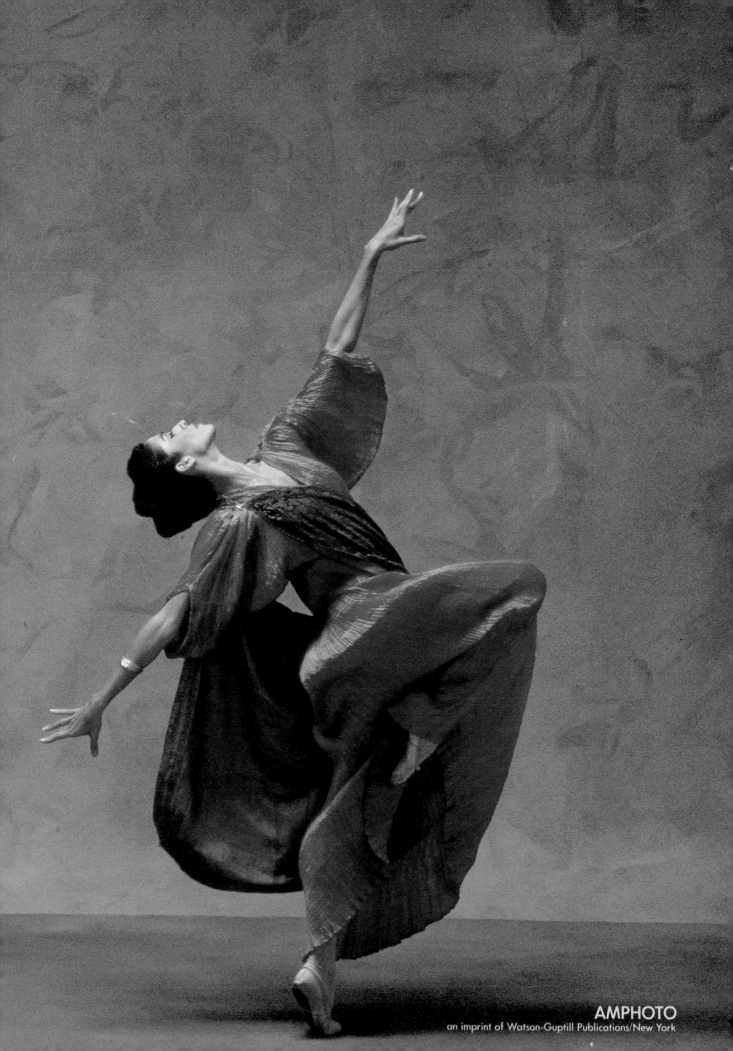

AMPHOTO
an imprint of Watson-Guptill Publications/New York

Copyright © 1984 by Henrietta Brackman

First published 1984 in New York by AMPHOTO,
an imprint of Watson-Guptill Publications,
a division of Billboard Publications, Inc.,
1515 Broadway, New York, NY 10036
ISBN 0-8174-5400-4
 0-8174-5401-2 (PBK)

Published in Great Britain by Columbus Books,
Devonshire House, 29 Elmfield Road, Bromley,
Kent, BR1 1LT, England.

ISBN 0 86287 075 5

Library of Congress Catalog Card Number: 84-45442

Manufactured in Japan

1 2 3 4 5 6 7 8 9/90 89 88 87 86 85 84

For my brother, Arthur Brackman.

ACKNOWLEDGMENTS

My thanks to Eleni Mylonas for helping me put into words some hard-to-express, abstract ideas; to Diane Lyon for her invaluable assistance; to Thom O'Connor and Al Gruen; to Howard Chapnick, Jim Hughes, Peter Lacey, Ira Shapiro, and members of SPAR and ASMP for their advice and suggestions; and to all the photographers who so generously gave me time and thought in supplying their photographs.

I must admit I bit off more than I could easily chew when I undertook to write a book of this scope—both theoretical and practicable, and staying clear of generalizations in order to address the specific problems of photographers in each major field, since each calls for a different type of portfolio.

This leads me to another thank you—to Pauline Augustine, who came along at just the right time to help me with the final editing and the task of whipping everything into shape. Pauline had exactly the combination of qualities I needed: as a former working photographer, she understood photographers' thinking; and as an editor of the *ASMP Book* and other books, she understood editing. I am indebted to her for going beyond the call of duty in her assistance.

CONTENTS

HOW I CAME TO WRITE THIS BOOK

When I represented photographers, including Pete Turner, W. Eugene Smith, Robert Huntzinger, Harvey Lloyd, Garry Winogrand, and others, my first task in every case was to help develop a powerful sales portfolio to present to clients. I had an advantage over the photographers I repped: I could be completely objective about their photographs. And more than that, since I was out in the market every day showing portfolios to clients—on the firing line, so to speak—I learned firsthand what would bring out an enthusiastic response and what would leave clients cold.

As I observed clients' reactions, I saw that the choice of certain types and combinations of images helped dramatize the photographer's work and made an impact that could result in getting the assignments we were after. I also learned that when a portfolio failed to click I could make it more effective by changing the arrangement of pictures. And when I saw clients pass over certain pictures, I would experiment, replacing uninteresting images in the portfolio with stronger ones, and thus strengthen the impact.

When I stopped "repping" to become a career consultant, I noticed something that surprised me: Whenever I redesigned a portfolio, whether for advertising, corporate, or editorial work, I followed the same steps—first in the thinking and planning, and then in actually putting the portfolio together. Eventually, I started to analyze the reasoning behind each step I took, and then I made notes on the process. Finally, I organized all the material—the approaches, techniques, principles, rules, and tricks of the trade—and have made every effort, in this book, to put this information into a coherent system that you can work with easily.

I hope this system will be as helpful to you as it has been to me.

WHAT A POWERFUL PORTFOLIO CAN MEAN TO YOUR CAREER

Probably more errors are committed in portfolio presentations and more sales lost as a result of those errors than by any other means. Today's competition is intense and it doesn't make sense to show anything less than the strongest portfolio you can possibly put together.

A powerful portfolio helps sell your work and builds your reputation. It helps increase your income, expand your markets, raise your price structure, and—if it's geared right—it helps you get the kind of work you most want. Conversely, a weak portfolio can slow you down and often results in your losing a job you hoped to get.

I've seen professional photographers increase their sales by tens of thousands of dollars a year once they started showing the right portfolio. When I represented Pete Turner, we concentrated from the very beginning on developing "great" samples and then putting them together in a way that made a strong statement. It paid off for Pete in sales, in reputation, and in steadily higher fees as we added new work to his presentation.

A BETTER PORTFOLIO CAN MEAN HIGHER FEES

Art directors react to what they see. If you show a low or medium level of work (or if the work just *looks* that way because you chose the wrong pictures or they are poorly organized) you can only expect to draw offers of low or medium fees. But show a top-level portfolio and it conveys the definite impression that you command—and are worth—the higher fees.

Your portfolio helps build your reputation. There is an interesting chain reaction involved in building a reputation. You show a strong portfolio and that helps you obtain assignments that produce good published work. The published work begins to be reprinted in the trade press and in various publications read by art directors, picture editors, and designers. Your name begins to be seen and known. Once you get a reputation started, one piece of publicity invites another, and it can snowball.

Your portfolio is your main selling tool. You can take ads in photographers' creative books and do mailings to promote sales, but the bottom line rests on your portfolio. When clients respond to your ad, what do they want to see? Your portfolio!

A knack for selling is not essential. When you have a strong portfolio, you don't need to be a super salesperson. Clients don't want to be on the receiving end of the "gift of gab." Rather, they want to see outstanding samples of the kind of work that will be useful to them. Your portfolio does most of your selling.

Clients will recommend you. With so many photographers chasing after the same assignments, it's hard to get in to see clients. But once you *do* get an interview, think of how much better the client's response will be to a terrific portfolio than to one that's just fair. Not only do you stand a good chance of getting work with that client, but the client is often glad to suggest other people for you to see.

WHAT IS A PORTFOLIO?

Physically, a portfolio can be a book, a box, or a tray containing samples of your work—prints, tearsheets or laminations, color slides or mounted transparencies—all bearing your name. There are many ways of combining these various forms, as I shall describe in later chapters. But what counts most in the portfolio is its content: It's essential to know which pictures to use and in what order to use them so that you can make the strongest possible statement about your work.

The Key to Your Career. Putting together the right portfolio is the key to everything you do in your career. In order to

produce the best presentation, you need to think through what you want to do (your direction), what kind of work you want to sell (your specialties), and to whom you want to sell it (your markets).

Once you've worked out your portfolio, you'll know how to describe yourself and your work to clients, which markets are right for you, and how to use other promotional tools to reach those markets.

How Much Does a Portfolio Influence the Client's Choice of a Photographer? Read these quotes, taken from an interview in the *New York Photo District News*, in which art directors answer the question of how they choose their talent.

Art Director: "I like finding new people . . . [but] I have to be knocked out by their book."

Art Director: "[The portfolio] is the key to finding a new photographer."

Creative Director: "We always remember seeing terrific work."

And here is a quote from the art director for a major cosmetics account: "We used to work with only one or two photographers, but that has changed. The art directors here now continually ask each other for lists of new people—to recommend books they've seen."

SUCCESS IS NO MYSTERY

Look at every successful photographic career and you'll find these three main components:

1. An outstanding quality of work
2. An effective portfolio that shows the work to best advantage
3. An intelligent sales program that includes advertising, mailings, self-publicity, and regular sales contacts

Whether you're in the field of advertising, corporate, or editorial photography, the secret is to make all three of the above ingredients work together at the same time.

If you are starting out, you must find a way to make your few samples of published work look important and convincing, without pretending that you're further along in your career than you really are.

If you are well-established, anything you can do to improve your present portfolio is worthwhile. You must show images that help you stand out from the competition (as well as bring in sales).

No matter how "big" you get, you always need a fresh, "hot" portfolio. It's easy to make the mistake of thinking, "My clients know me. My reputation is secure." It's an axiom that careers don't stand still. They either move forward or fall back. New competition creeps in, new styles develop, your clients leave their jobs so you need to find new ones. Besides, it's important to revitalize your portfolio to keep yourself in touch with what's happening.

HOW DO YOU KNOW WHEN YOU HAVE A "NEARLY PERFECT" PORTFOLIO?

- When the art director says, "Are you free for a job next Wednesday?"
- When you first start showing your book and the client says, "Wait a minute, I want so-and-so to see this."
- When you find it easy to get up in the morning, knowing you will get a good reception on your sales calls.
- When you—or your rep—start getting a higher percentage of sales on the calls you make.

HOW TO DEVELOP A POWERFUL PORTFOLIO

There is, of course, no "perfect" portfolio for everyone, nor is there a magic formula for creating one. Every photographer's portfolio presents a different problem and solution simply because every photographer is different. The nearest thing you can get to a perfect portfolio is one you'll get by critically analyzing your direction and your markets—along with a raft of personal variables such as your interests, temperament, priorities and goals—and then putting your samples together in a powerful presentation. That's a tall enough order. Don't try to make it perfect—just powerful. That's the word I prefer to use in this book.

WHAT MAKES A PORTFOLIO POWERFUL?

There are so many different opinions on this subject that it is easy to get confused. The truth is that there is plenty of room for a variety of treatments. But while opinions and styles may vary, there are certain principles of human psychology and selling strategy that govern every successful portfolio and these can't be changed.

First, the work has to be good. You need to be absolutely ruthless in choosing your samples. What clients end up *using* and publishing may not always be that great, but what makes them want to buy your work is seeing pictures that, as they say, "knock them out." Stanley Carp, a well-known photographer's representative in advertising, advises: "Show five pictures that are sensational, five that are terrific, five that are wonderful, and five that are very, very good."

Second, the work must be relevant to the interests and needs of the clients you show it to. This doesn't mean you must tailor the portfolio specifically for every client but that you need at least a minimal awareness of what the client does and what he or she is using in pictures, and make sure you have a good proportion of work in your portfolio that will be of interest to him or her.

Third, your samples must demonstrate convincingly that your work can be an advantageous choice for the client on the particular kind of work you want to get.

Fourth, your subjects must be organized so that they deliver a clear message to the client of just what it is that you do and what subjects, styles, and techniques you have to offer.

Fifth, your presentation—its physical form—must be efficiently designed, attractive, and easy to look through.

TWO PARTS TO DEVELOPING YOUR PORTFOLIO

There are really two parts to building your portfolio—the first is the pre-thinking part, the second is the performance part, or the editing and arranging of the portfolio. I recommend that you visualize your task as consisting of two kinds of action: one thinking, the other doing. Both are equally practical and equally important for you.

In the first section ask yourself questions like: What do I want my portfolio to do for me at this stage of my career? Where do I want to be heading? What do I want to put the emphasis on? You'll be defining or redefining your direction, listing your markets, figuring out which ones you want to try to fit into and on what level. If you follow the chapters in the first section of this book you'll not only be doing some personal soul searching but you'll be reflecting on the competition that keeps creeping up and thinking of some ways to stand out from it.

In the second section of the book you'll find a new system I've developed for editing the pictures for your portfolio (for any kind of editing, for that matter.)

This is a precise method of editing almost guaranteed to help you gain a new authority over your images.

Use What Applies to You. As you go over this book, I suggest you pick out the parts that apply to you. A portfolio, when you do it right, is based on many variables pertaining only to your personal scheme of things; so don't let yourself be confused by trying to follow suggestions that apply best to someone else. Relate the techniques and tips to what you need.

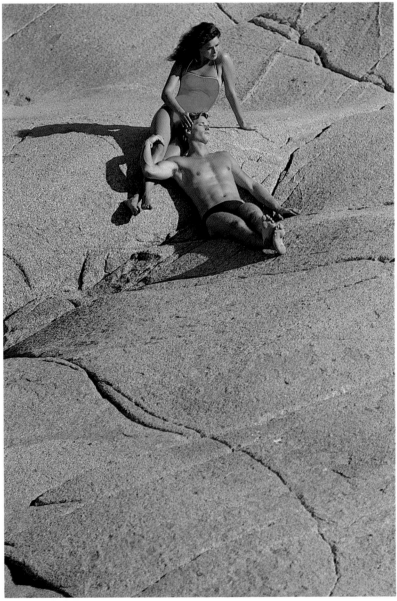

First the work must be good. Second, the work must be relevant to the interests and needs of the clients you show it to. For example, J. Barry O'Rourke shows pictures like these to editorial and advertising clients.
© J. Barry O'Rourke

HOW TO CLARIFY YOUR DIRECTION

Some photographers are lucky. They know what they want to do in photography from the moment they press the button on their first cameras. Others, not quite so lucky but also a step ahead, start as assistants to established photographers. When these beginners are ready to step out on their own, they follow the same direction as their mentors or, having learned from experience, they try something else. But most photographers aren't that fortunate; they have to figure out their direction for themselves.

Choosing your direction could be one of the hardest decisions you'll have to make in your entire career—and it's probably also the most important decision you'll make. You can't expect to pick the right pictures for your portfolio (to say nothing of organizing them effectively) without being clear on your direction. Do you intend to work in the advertising, corporate, or editorial field? How about all three fields? Within your chosen field, which subject or subjects will you want to emphasize most strongly in your portfolio?

As a professional, you may be showing a weak and ineffective portfolio and never realize that the haphazard organization and lack of a unifying message in your presentation is keeping you from getting the business you want.

If you are a beginner, deciding on your direction can be especially difficult. At your stage of growth you may have studied or experimented with many types of work, but you haven't had the chance to try them out professionally, to see which suits you best. And yet you must decide on a direction, if only broadly. Otherwise, like Don Quixote, you will be charging in all directions and getting nowhere with your career.

DO SOME SOUL SEARCHING

I believe totally that you shouldn't touch a picture in your portfolio until you have thoroughly explored—and answered— this important question: What kind of work do you spontaneously like to do? It often takes some digging and soul searching, as well as some honest thinking, to get to the kernel that holds the answer. We'll go into more detail on this as we go on, but in my experience, this is the core question. It is your starting point, everything else comes after.

If you choose a direction that's wrong for you, by bowing to outside pressures or looking at the issue with a false sense of realism, you may get stuck with a direction and you don't really want. The path to success is strewn with dropouts and failures, and if you aren't enthusiastic about your direction, you may not take the right steps to success. You might well become a dropout yourself. That's why, whenever I make a speech or write on this subject, or work with a photographer on a portfolio, I always start with the same plea: Respect your individuality.

RESPECT YOUR INDIVIDUALITY

No two photographers are exactly alike, any more than two people are exactly alike. (Mickey Rooney, the stage and screen actor who recently wrote a moving story of his life, says, "Like thumbprints, we are all identically different.") It's up to you to recognize that there is always something singularly yours— whether it's your technique, your photographic experience, your aesthetic approach, or your talent for certain kinds of pictures. Everyone has a unique quality that can be defined if you think about it.

Ask Yourself: What Do I Like to Do? What do you most enjoy photographing? The work you like to do is the work you will excel at and work harder to properly accomplish. You will put your strongest motivation into that work. You will think about your work even when you are not working, and you will pick up new ideas constantly because your mental and emotional antennae will always be tuned in. For example, you'll be walking down

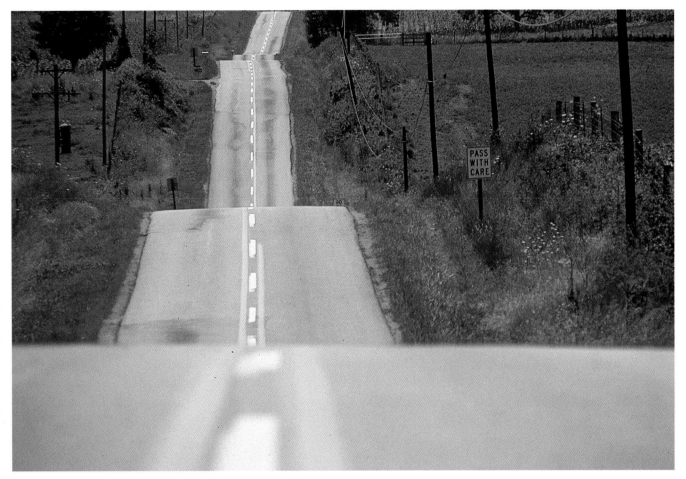

the street, headed toward a local diner for a hamburger at eight o'clock one night, and you'll see something and say, "Hey, that would make a great picture for part of a series I'm doing." On the other hand, if you are not involved, if your senses are not tuned in to the work at hand, even photography can become just another nine-to-five job. I'm always impressed when I hear photographers say that they carry their cameras with them everywhere, even on holiday. It's said that Henri Cartier-Bresson never used to go out without a camera around his neck.

As for working hard in your chosen field, we all know that it seems easier to put in disciplined effort and long hours when you are doing something you like to do. The energy comes spontaneously, as an organic part of your activity, rather than as something that has been forced upon you by circumstances.

Look Inward First. Don't start looking for your direction by thinking, "What will sell? What does the market want?"

Instead, begin by asking yourself, "What is it that I really want to do?" The idea is not to produce what the market wants, to do almost anything to sell, but rather to ask yourself some searching questions about your natural talents, abilities, and interests. Work from the inside to the outside. Once you have looked inward, you can do some realistic thinking about your potential markets.

This approach to defining your direction is anything but self-indulgence. Don't let anyone tell you that you don't want to compromise. Certainly you will make compromises. I've never worked with a photographer who didn't do a lot of things he or she didn't want to do during his or her career. And I'm not suggesting that you should disregard sound advice but merely that you should be sure the advice you get is knowledgeable and factual, not based on stereotypical fears.

Let me tell you a story to illustrate the point. Years ago, when I first started as an agent, I represented Garry Winogrand. He came to me with a huge

Here Jay Maisel photographs one of his favorite subjects, the open road. The picture also reflects one of his strong interests: the many ways that light can affect his subject.
© Jay Maisel

A strong interest in the feminist movement led Diane Henry to photograph the first convention of NOW, the National Organization of Women, and the building of a reputation in the field. The photograph was first used in *Ms.* and has since become a classic.
© Diane Henry

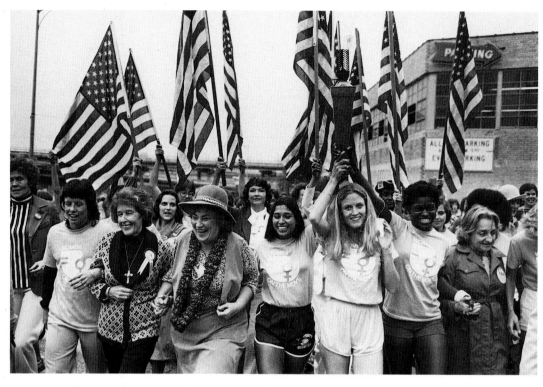

number of sample 11 × 14 prints—four piles, each about two feet high. (Garry was one of those photographers who always carried a camera around his neck.) Garry wasn't making enough money to pay his rent. His previous agent had wanted him to take "pretty girl" pictures, an area of photography that Garry was not interested in, at least not in the conventional way.

When Garry photographed pretty girls, he always chose handsome but very earthy, naturally sexy creatures and he captured this essence in his images. Instead of steering Garry to work in a conventional way, we worked toward getting him assignments that called for pictures of this type of girl. For example, a story on the revival of an old burlesque

theater and a piece on backstage at a nightclub.

But what Garry really liked then was sports and sports figures. For months he had been photographing, on his own, the prize fighter Floyd Patterson (who later became, briefly, world champion). We built a portfolio featuring his sports photography. Within a few months he was covering Rocky Marciano's prize fights in Madison Square Garden for major national magazines. Garry's later work as a photographic artist was just a logical extension of the very personal style he brought to all his work.

Your Personal Style. I should say here that your direction in photography can be based not only on the subjects or the

These pictures from a *LIFE* story on the war in El Salvador are the work of J. Ross Baughman who clearly knows his direction: He is a dedicated photojournalist. He makes it pay by syndicating his material abroad, through the agency he established, Visions Photo Group.
© J. Ross Baughman

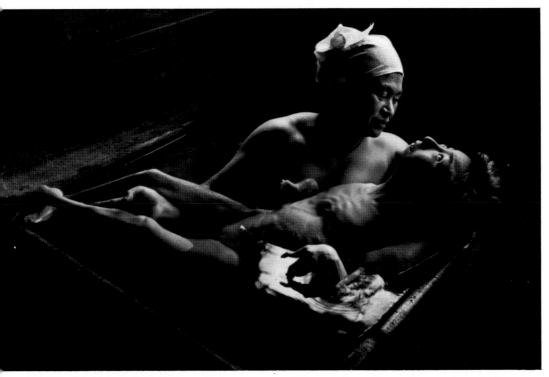

"Tomoko in the Bath," 1972, from W. Eugene Smith's world-famous picture essay on the victims of mercury poisoning in Minnamata, Japan. This essay epitomizes Smith's major direction: to express his deep involvement with, and compassion for, people. © W. Eugene Smith; photo courtesy Center for Creative Photography

markets that interest you but also on an individual style that carries the trademark of your unique eye, whatever the subject or market might be.

Not every photographer possesses an individual, recognizable photographic style, nor indeed is such a style required for success. Yet, in analyzing your direction, it is important for you to consider whether you have such an approach to your pictures. If you do, that kind of unique quality can make the question of portfolio subject matter almost irrelevant, and your unique style will run through everything you do and you will want to emphasize it.

But whether you are a true stylist or not, there are probably some elements in your approach to making pictures (as there are in almost everyone's work) that you can use and dramatize in your portfolio. I can think of qualities described as "a good, clean style," "an elegant, precise approach," "a sense of drama," or "a feeling of light," that can become dramatic elements in your presentations.

Many of the best photographers can, in fact, be described by their personal photographic style. One can immediately visualize the strong, cool eroticism of Helmut Newton's work, the color and design of Pete Turner's images, the touching and penetrating humanity of W. Eugene Smith's documentary photojournalism, or the surrealistic figments of the imagination of Sarah Moon's fashion pictures. Other photographers might be known for special effects.

Ross Baughman terms himself an "investigative photojournalist." These pages are from another of his picture stories that appeared in *LIFE* and were later resold abroad. © J. Ross Baughman

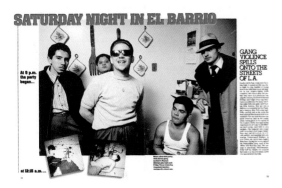

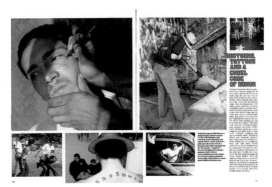

TO HELP YOU DECIDE YOUR DIRECTION

These questions and exercises aren't too difficult or time consuming. I use them whenever I am helping someone determine where he or she is heading. Photographers are often amazed at what they find out by trying these tests.

1) Clip out Ads or Picture Spreads You Like. Go through a batch of current magazines and tear out fifteen, twenty, or more ads and picture spreads that you would like to have been assigned to shoot. Don't think about whether or not you could actually have landed these assignments. Just clip out the kinds of shots you would *like* to have done.

Next, sort these clippings into groups according to their subject matter—still life, products, people, industrial, scenic, landscape, fashion, and so on. Or, if it's only the style of the photographs that appeals to you, group the clips purely by style.

Now, look over each group of clippings and see what common denominator you find in them. You may see that what you really lean toward is big advertising production shots or very precise, elegant, studio still life shots. Or your choices might involve travel subjects or serious documentary essays. Or the thread running through everything you have clipped may be a particular graphic treatment of a number of different subjects.

This exercise should help you see clearly what interests you most. In case you don't get some good clues, however, it may be that you are not grouping your clippings properly, or you need to review a larger number of magazines, or perhaps you are not quite sure what you are looking for. I suggest that in a week or two you try again with a new set of examples. It really is worth the effort.

2) Your Ideal Assignment. Try to answer this question: If you had a rep who could bring you absolutely any assignment you wanted by next week, what would you like that assignment to be?

Make yourself think. Don't try to be realistic, or cogitate over such obstacles as whether or not you have enough experience, or the possibility of your being offered such a job. Just ask yourself what assignment would make you the happiest. Let your deep feelings respond.

You should find some clues to your direction in your answer, even if your ideal assignment is something wildly improbable. If, more than anything, you would like to accompany the astronauts on their next shuttle trip into space, that answer may be telling you that you have a stronger interest than you might realize in science, or adventure, or high-tech, futuristic photography.

3) Write a Four- to Six-line Description of Your Work. List the primary characteristics that make it valuable to clients. Don't list the clichés that everyone can claim, such as reliability and quick service, unless they are actually your main specialties. (Reliability and service are assumed to be givens for most photographers.)

Cite the particular areas you are strong in, such as technical skills, design sense, color control, and so on. Other characteristics of your work may include ease in handling the large production shot; a talent for rendering a client's ideas in visual terms; your capacity to organize large groups of people for a photograph; or your ability to capture good expressions in executive portraiture.

In making this list, it's a good idea to use the third person rather than "I" when referring to yourself. That way, you won't feel inhibited and you won't feel as though you are bragging. Some phrases you can use: "specializing in . . .," "particularly strong in . . .," "has a special way of handling. . . ." If you are a problem solver, be sure to spell it out, as: "especially good at solving problems, whether in visualizing concepts or in handling technical problems."

Thinking through this description of your work will help you to see yourself in perspective, and it may also give you a lead to your direction. (It will also help you later when you are talking to clients.)

4) Pick out Your Best Pictures. You'll be better able to do this after you have read the chapters on editing, especially those covering sorting and grouping, and

choosing. But try picking your best work now, anyway.

5) Check out Your Attitudes. List a variety of subjects and ask yourself how you feel about them. Those you react to strongly can be a tip-off to the areas you are interested in, not only as an individual but also as a photographer.

How do you feel about life, the world we live in, contemporary problems? What are your feelings about war, peace, wealth, poverty, politics, the environment? What is your attitude about black people, white people, the aged, the young? How about auto racing, architecture, psychology, child rearing, community services, food, fashion? Use these questions to help you get started on your own list of attitudes.

6) Look Back into Your Past. When I'm stumped and can't seem to figure out a photographer's direction, I ask the photographer these kinds of questions: What subject did you major in at school? What were your favorite extra-curricular activities? How did you happen to become a photographer? Which photographers have influenced your work?

7) Look at Your Present. What are your hobbies? Your major goals? Is photography in your blood or is it just your occupation. (Either answer is okay. The objective here is to take soundings, not to make value judgments.)

Ask yourself what kind of temperament you have. Are you aggressive in business or do you tend toward the artistic? To be an advertising illustrator, for example, you must be a special kind of photographer who can run a studio, deal with clients, models, stylists, and support personnel, understand a profit-and-loss statement, and still produce creative work under deadline pressures.

8) Look to the Future. I often ask a photographer who is uncertain about a direction: Where do you want to be three years from now? This is a good question to ask yourself because it fills out the career profile you have been developing. In three years, do you want to be making a lot of money? Do you want to become

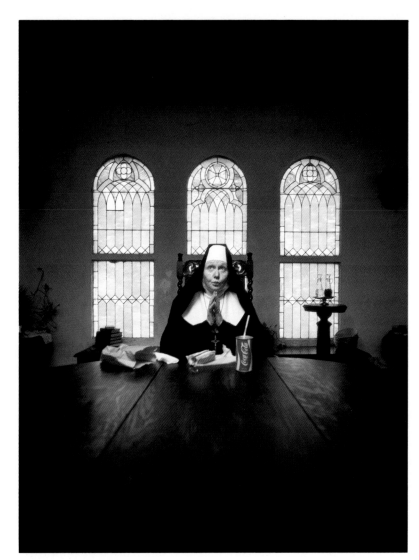

One of the talents of Ken Ambrose, the well-known advertising illustrator, is a delightful and unerring sense of humor. © Ken Ambrose

The photographer who prefers to work in the great outdoors will do well to direct part of his or her sales efforts toward the agricultural field. Here are two fine examples of ads by Arthur Tilley. Farm photography is used in advertising, corporate, and editorial markets.
© Arthur Tilley

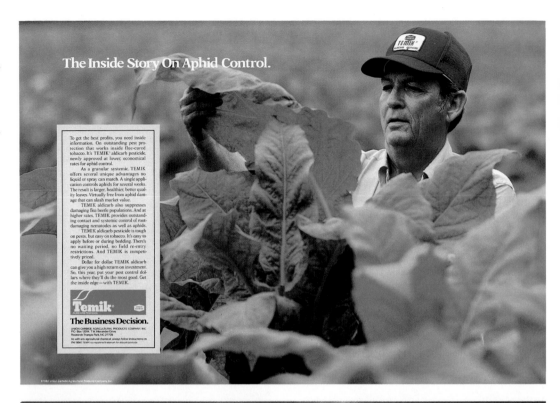

famous, with a national reputation? Do you want to be traveling to exciting places? Do you want to add your voice to a social cause?

KNOW YOUR LIMITATIONS

There is a place in photography for people of all levels of skill and artistry, and there is nothing wrong with being just an average photographer, provided that *you know your level* and you build your direction toward being the best in your class.

Set Your Sights. You may be the Ferrari or the Rolls-Royce of your field, or you may be the Volkswagen. Consider how successful retail stores handle their operations. Each builds sales around a predetermined style, price, and clientele. There is Neiman-Marcus and there is Macy's; there is Sears and there is Woolworth's. Each store has a valid position in the marketplace.

I once met a photographer who specialized in producing very ordinary pictures, still life shots of tools and dies for a number of small machine shops in his city. He charged only a small fee per picture, but because he had once been a machinist he knew exactly what his clients wanted and he was successful.

He was completely satisfied in this narrow area of work. He knew his limitations and worked within them. He had chosen a direction that was exactly right for him.

Be Honest with Yourself. Some things you can learn and develop skills for, other things are just not your métier. You may think you want to do major advertising illustration, but when it comes to operating a big studio with a staff, building huge sets, and coping with a constant, enormous overhead, you may never have the temperament for it. On the other hand, you may be a tip-top location photographer in advertising or corporate work, or you might do fine running a small studio.

Similarly, you may be all thumbs when you have to photograph a large group of people, but you may be truly gifted when you need to shoot a dozen pineapples in your studio. Or you may long to travel, but you have a wife and two children at home. These are all serious considerations.

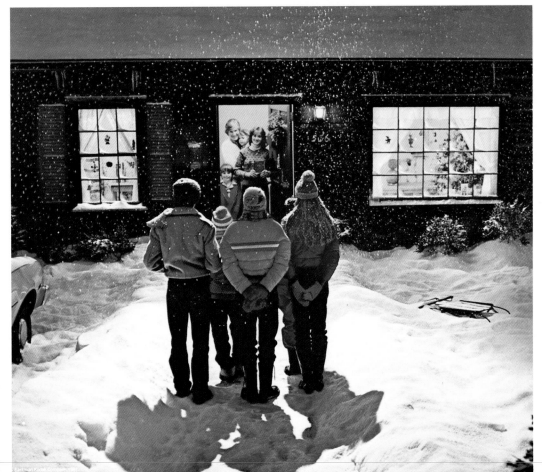

The set for this large production shot was built in the studio of advertising illustrator David Langley. Careful propping and styling, and well-chosen models, contribute to the "on location" look.
© David Langley

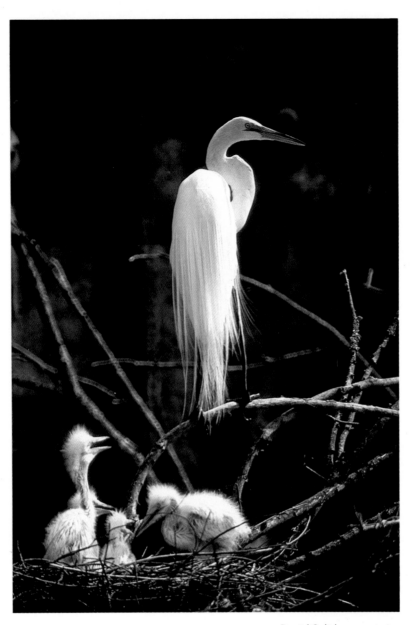

David Soliday spent six months on a platform he built in a tree to photograph part of the life cycle of the American egret for Geo magazine. His pictures were so beautiful that they led to other bird assignments. © David Soliday

Keep at It. If you are not as yet sufficiently developed in your chosen area, you can still begin to work toward your goal. You can spend time doing test shooting, self-assignments, and studying.

THE KEY TO YOUR CAREER

As one successful photographer told me, "As soon as I had my direction really figured out, I began to find a unifying thread running through all the decisions I had to make in selling myself, in trying to expand my markets, and in building my reputation." Setting a direction is where your portfolio starts.

Direction helps you choose pictures for your portfolio. Having a direction makes it easier to decide which pictures to use and which to discard. You also know which images you want to give more space. When you organize your presentation, you have a sense of how to unify the images to make a clear, consistent impression.

Direction helps target your markets. You won't waste time going to see clients who can't use the kind of work you have to offer. As a rep, I worked entirely with highly creative photographers, regardless of their area of specialty. This gave me a general sense of direction and I sought out only the more creative clients in agencies, publications, and industry.

A corporate photographer I worked with decided he didn't really want to spend his life doing annual reports and shooting the insides of factories. His real direction was working in the great outdoors. We made a list of corporate markets more suited to his needs, including industries which produced tractors and farm machinery, fertilizers and insecticides, lumber and building products, sailboats and yachts, and sporting goods and leisure products. This new direction permitted him to enjoy his work—and his life.

Another photographer, in the fashion business, covered too many markets

with too many styles. Her best images showed great "body work": young, active women in bathing suits and sports clothes; also a certain seductive look in lingerie shots. Her other fashion pictures were nothing special, but her body images clued her in to the right markets for her, and by concentrating on that type of work, she was able to substantially increase her business income.

Direction improves your sales talk. It's a lot easier to sell yourself when you know what to say about your work. When you can describe in a few words what you do best and how you can help your client, that's good selling.

Direction defines your sales promotion. Knowing your direction helps you aim your promotional ads and mailers. The bugaboo of deciding which pictures to use is diminished. By the same token, when you get a chance for some publicity in an interview you'll know what to say to help build your image.

Try to count all the props that turn back the clock in this period piece, made by Ken Ambrose for self-promotion, with a Humphrey Bogart look alike as model. Ambrose maintains a set builder on staff.
© Ken Ambrose

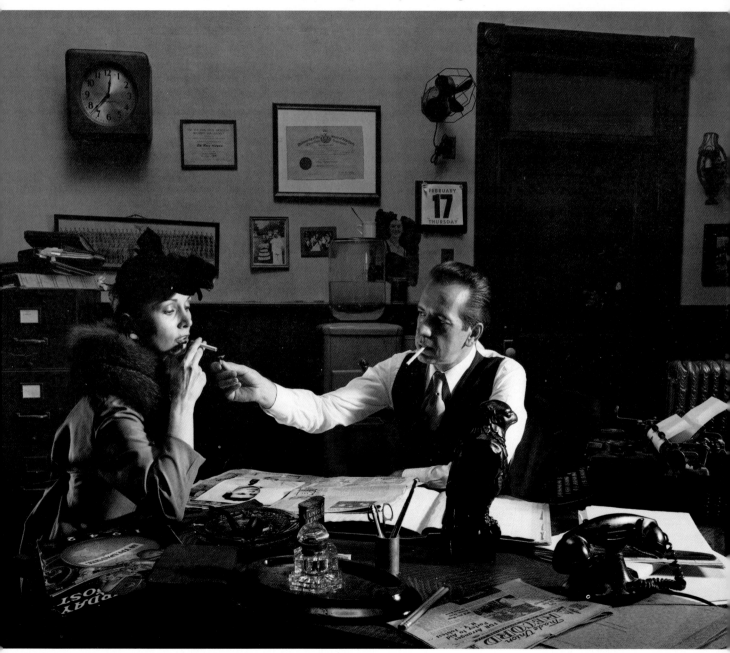

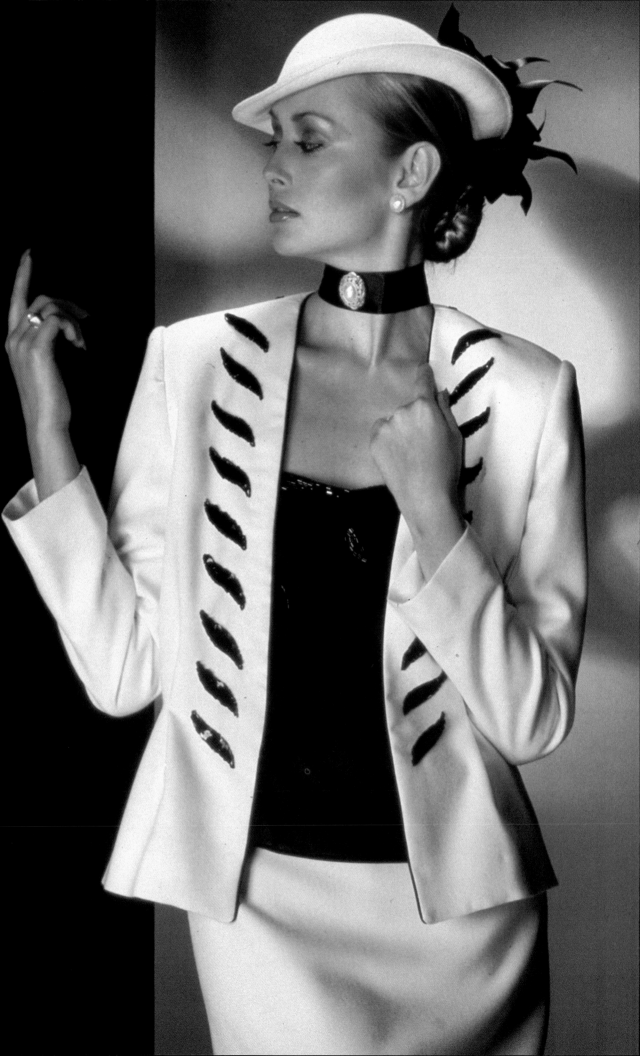

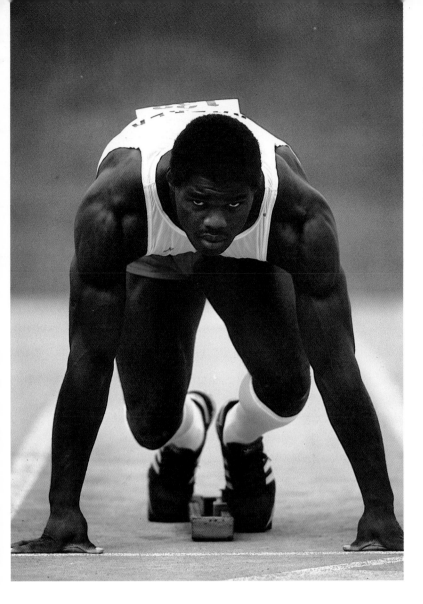

This dramatic shot of Herschel Walker at the starting line is by Ron Sherman who does advertising, corporate, and editorial work, with the strongest emphasis on his corporate work. © Ron Sherman

:hard Blinkoff's spe-
ilty is fashion and
auty, both in the stu-
and on location. His
perior technique in
jhting for the correct
in tone and his under-
inding of the mood
at best expresses a
articular fashion are
monstrated here.
Richard Blinkoff

ART VERSUS COMMERCIAL PHOTOGRAPHY

You can't dictate the realities of the marketplace, but there are ways to strike a balance between making a living and doing what you want to do. Don't get scared off by the old canard about wishful thinking before you even begin to think.

For instance, you can't say, "I want only to take nature pictures" or "I'm involved in abstract photography only" and still expect to pay your bills by selling your work to advertising clients.

Many "name" photographers have gone into teaching and have built an art portfolio and a reputation in the art photography field by working on their own in their spare time. Others have taken paying jobs in galleries, museums, sales,

or photo-finishing. And sales of pictures through stock agencies, as well as sales for home and office decor, can add to incomes.

The big questions, though, are whether you really want to become an art photographer and whether your talent is truly strong in that direction. Far too many young photographers yearn for the glory of being an artist, but when it comes down to paying the price—for example, the years of shaky income while you are building your reputation—many people are not ready for that sacrifice. Don't fool yourself. Make sure that if you are aiming for a career as an art photographer, you are well aware of the tribulations you will face along the way.

HOW PETE TURNER FOUND HIS EARLY DIRECTION

This is a long story, but worth telling as an example of how a direction evolves and how knowing your own likes and dislikes can help you find the right direction.

I first met Pete Turner when he was only a year or so out of the Rochester Institute of Technology and the Army Signal Corps. His training had been so good that he could do almost any kind of assignment, from an advertising illustration using an 8 × 10-inch format to a magazine feature using 35mm equipment.

It was clear from the beginning that Pete was destined to become a major talent in the field. But we knew we couldn't build his reputation—or a strong position in terms of sales and high fees—by shooting all over the lot, getting a job here, a job there, and not being known for anything in particular. In the end, Pete's direction became advertising, but in the first few years he worked mainly on editorial projects.

He didn't know what he wanted to specialize in, if anything, but he was very clear on one ambition: The single client he had always dreamed of working for was *Esquire* magazine, at that time one of the brightest and most sophisticated magazines on the stands, both graphically and editorially.

The first time I called on *Esquire* with Pete's portfolio, the results were nil. We didn't yet have the right samples. But then we got lucky. (You know the story of luck, you have to be ready for it.) The one big assignment that Pete

The two pictures on this page were taken by Pete Turner in Africa on his first big assignment. It is interesting to see that his control of color and his gift for stunning graphics were present in his work from the very beginning. © Pete Turner

When Turner goes on vacation these days, he chooses locales that will afford opportunities for great personal pictures. He loved the brooding mystery of Easter Island and Stonehenge as shown on the page opposite. © Pete Turner

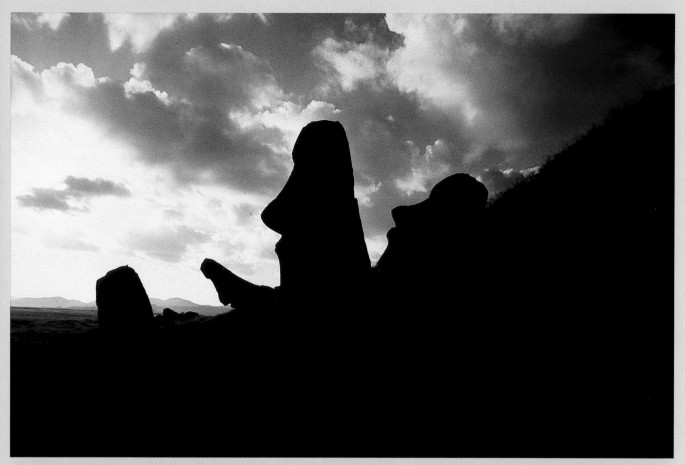

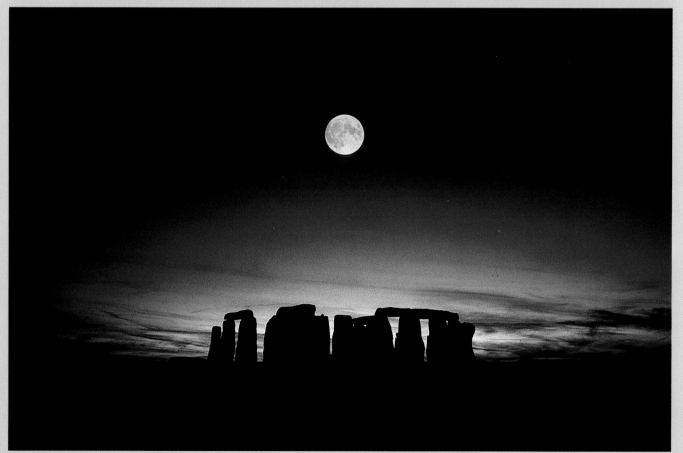

had done earlier was to spend six months in Africa photographing a trailer caravan that went up the spine of the continent from Capetown to Cairo.

The assignment had been obtained for him by the Freelance Photographer's Guild. My late brother, Arthur Brackman, head of the agency, had discovered Pete when he was still in photography school. He immediately recognized Pete's talent. Arthur obtained the assignment for him from a trailer company, and parlayed it into bigger stakes. He got *National Geographic* to agree to have Pete shoot "whatever he sees" in color, with the magazine supplying film and processing.

Pete came back with thousands of pictures of extraordinary beauty and variety. We were finally able to get the outtakes back from *National Geographic*, and Pete and I closeted ourselves in a room and edited about 5,000 images down to two 80-slide trays. My second call to *Esquire* was an unbelievable success. The art director looked at a few slides and called in the travel editor. After a screening, the magazine's editor, Harold Hayes, called us into his office and said to Pete: "We'd like to work with you. What would you like to do for us?" He added, "We want to get more action into the book, would you like to do some sports?" Pete said no, he didn't care much for sports photography. So the editor suggested that he think about what he'd be interested in doing and get back to him.

I spent a couple of afternoons going over a list of potential sports ideas with Pete. "Do you like golf or tennis?," I asked. "What about swimming? Water skiing? Motorboating? Sailing, yachting, iceboating, skin diving?" And so on—every sports activity I could think of. And Pete didn't care for any of those ideas.

But he did come up with an idea of his own. He wanted to cover a long-distance railroad trip, to board a crack train and show visually what it was like to ride from one end of the country to another. Pete's father had been a

Turner titles the image on the facing page, top, "Anatomic Man." It was shot in the Salt Flats of Utah. The picture below it is a futuristic concept. At left you can see one of Turner's outtakes from the innovative Kohler Company advertising campaign featuring bathroom fixtures. Blue tonalities are prominent throughout Turner's work. In the two images below he has montaged shots of electronic equipment to produce works of art.
© Pete Turner

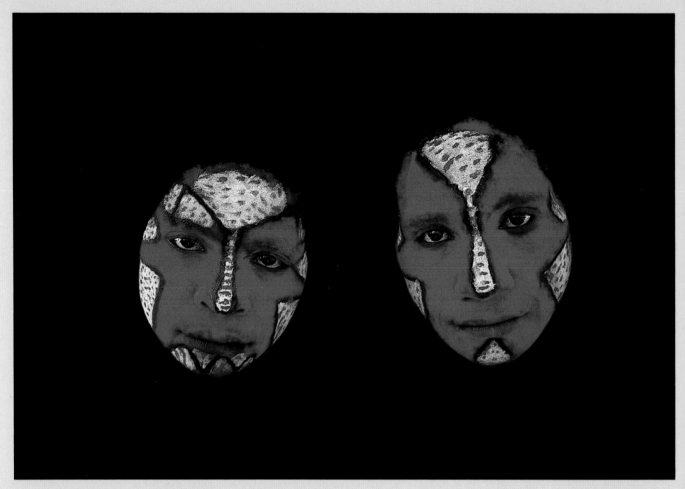

The painted faces from New Guinea appear surrealistic in this version. © Pete Turner

famous band leader during the thirties, and as a child, Pete had traveled with his dad. Pete remembered many nostalgic moments: the friendly Pullman porter giving a final brush to the overcoat of a departing passenger, the elegant dining salons on wheels, the cozy sleepers, and speeding by the lonely little towns in the dark of night. "These are all fading into history," said Pete, "and I would like to photograph what's still there while I can."

Esquire bought the idea at once. Pete had to do his own research on routes and railroad lines. He ended up taking an oval route cross-country, heading to the west coast along a northern route and returning to New York by a southern track. In all, he spent three weeks on the assignment and literally came back with a hole in the seat of his pants.

When we showed the "take" to *Esquire*—after editing the many rolls of film down to perhaps 150 images in a tray—the editors were ecstatic. They ran the picture essay over six pages

under the title "Pavane for the Iron Horse." It received enormous attention throughout the country among editors, art directors, and other photographers. Some of the shots Pete took on that assignment have now become classics. And the tearsheets are as impressive now as they were then.

Pete's picture essay delivered everything he had promised when he first outlined the idea to *Esquire*'s art director. Pete captured the atmosphere and mood of a great train, by using experimental techniques that have since become standards for many photographers. He caught the essence of a powerful diesel locomotive hurtling through the dusk. He photographed the bustle of a big-city railroad station and the intimate quiet of a tired waiter sitting alone, head down, at an empty dining-car table. Each picture was both an illustration and an interpretation. Pete had used every bit of technique, knowledge, understanding, and empathy he could muster.

It was after this assignment that Pete

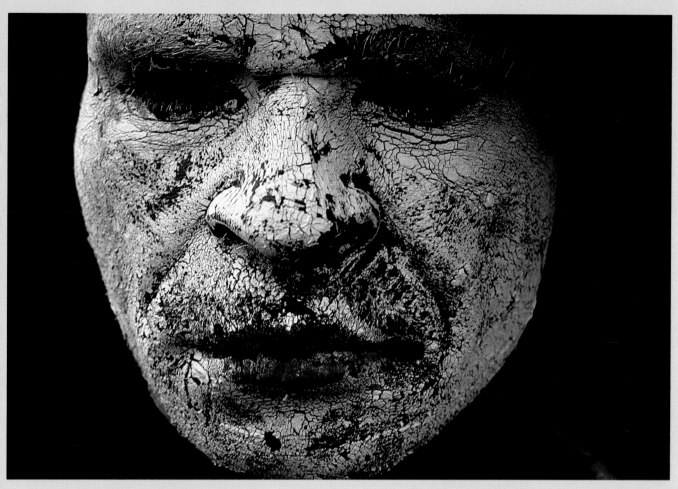

The extraordinary detail in this face, shot outdoors, makes it truly memorable.
© Pete Turner

said to me, "I like to see my name in print, and I like to travel." "Fine," I responded, "That means we'll concentrate on magazines and we'll go after travel assignments." During the following few years, Pete traveled hundreds of thousands of miles, doing spectacular color stories for magazines, especially for *Esquire* and *Holiday*. He did other types of magazine stories, including interpretive coverage of major movies being made on location and strikingly innovative experimental portraits of famous writers, artists, and politicians. He produced some graphically elegant work for corporations, and he began to get some location advertising assignments.

His photographs were so striking, fresh, and polished that people began to take notice and talk about them. Even his editorial pictures were marked by an illustrative quality that lent itself to advertising. Pete had the advantage of having studied for four years at the Rochester Institute of Technology, where he had learned to handle every kind of camera from 35 mm. to 8×10, and how to approach almost every type of assignment. We did many mailings of his work, and as Pete became more and more famous, the demand for his pictures in advertising became so strong that he focused mainly on that area.

There are some truths to be learned from Pete's story. Of course, we don't have as many big magazines and important photographic pieces as we did when Pete was starting out, but the principle of setting a direction and working toward it are still valuable. And the importance of doing a superb first assignment for a new client cannot be overemphasized. The first job you can do for a client "sets" the client's attitude toward you and influences the whole pattern of your relationship. If it's a great job, you are in. If it's a mediocre job, it won't bode well for the future. In Pete's case, that first big job was spectacular enough to launch him on a brilliant career.

THE MARKETS: WHERE DO YOU FIT?

No good portfolio is produced in a vacuum or without a clear picture of just which markets you want to sell to. If you have trouble planning your portfolio, the source of your difficulty may be that you have not decided on this single point: Who will be looking at your presentation? Once you know the answer to that question, the problem of which samples to use becomes much simpler. With all the individual variables that affect the work you put into your portfolio, there is still one invaluable rule: You must aim your presentation at the markets where you want to reach.

Top professionals usually know exactly who they want to reach, but even they sometimes miss targeting a potentially lucrative source of income simply because they haven't thought of the additional markets that might be tapped.

For example, I know one excellent still life photographer in the midwest who was dissatisfied with the volume of work he was getting from ad agencies, even though he knew he was getting about as much work as the agency market in his city afforded. He was thinking of moving his studio to New York or Chicago—which would have meant a great upheaval and a big risk—when he discovered additional markets he could tap in his area. These included the many corporations in his locality and in nearby states that needed still life photography for brochures and other materials. He began contacting these corporate accounts and also started calling on a number of fine graphic designers whom he had earlier neglected. As a result of considering new market possibilities, this photographer was able to increase his volume of work without moving to a larger metropolitan center.

Overlapping Markets. Remember that markets overlap greatly and there is no way to compartmentalize them completely. For instance, an advertising agency in a small city might handle all kinds of work besides advertising, spanning every market category described in this chapter. Likewise, a big city agency may have several departments that handle nonadvertising work such as sales promotion. To put it another way, the

This illustration by David Langley required that the details be absolutely right in order to lend punch to the idea. Even a slightly different expression worn by the model might have diminished the effect.
© David Langley

same type of assignment—say, photographs for a brochure—might come from an ad agency, a public relations agency, a corporation, or the office of a graphic designer. But basically, the three major markets—advertising, corporate, and editorial—possess their own distinctive requirements and rewards.

ADVERTISING

Advertising is the hardest market to break into, but it is also the market where big dollars are to be made. It takes longer to get started in advertising because art directors tend to work with a few photographers whose work and personalities they know, rather than take a chance and complicate their lives by using a newcomer. Such huge sums of money are invested in each ad—not only for media space rates paid, but expenses for models, stylists, makeup artists, sets, travel, and a score of other costs—that an art director wants as much assurance as possible that the photographic shooting will be a success.

The art director on a major ad campaign may not be the only person to decide which photographer to use. Frequently the agency's account executive or creative director must okay the choice, along with the advertising client—and sometimes even the client's husband or wife!

Studio overhead is high. While advertising photography—particularly studio work—pays the most, it is also the field in which the overhead is highest. Some top advertising studios gross a million dollars and more a year, but even those operations must keep a careful eye on overhead. Rents in the large cities are inordinately high and getting higher every year, and expenses include assistants, a studio manager, a set builder, an accountant, a lawyer, insurance, sales promotion, and a host of other services and activities, all of which can eat up the profits.

The pressure is great. Because of the overhead and the need to maintain steady sales, along with the usual tension that occurs with each job, advertising photographers find themselves under constant pressure. They must combine the

talents of an artist with the administrative and business skills needed to deal with models, stylists, staff, suppliers, and clients. In the best sense, advertising photography does carry a certain undeniable glamor, but a photographer going into studio work must consider whether his temperament is suited to the job.

Location photography. There is a trend among photographers who do both location and studio work to forego a studio and rent space when needed. And you can succeed as a strictly location illustrator, doing no studio work at all. You will have less overhead and fewer head-

This illustration from an ad campaign for Four Roses Whiskey by Robert Huntzinger depends entirely on the right expression of the model to get the point across. © Robert Huntzinger

For the exquisite skin tones you see in this image you must take infinite care and have actual knowledge of the special techniques of lighting involved.
© Richard Blinkoff

A sense of the line the body adopts in various movements; access to good models who are trained to stand, sit, and walk; and an interest in fashion trends are all needed to succeed in fashion photography.
© Richard Blinkoff

aches, but you won't get as much steady work or make as much money. Still, for many photographers, this is the preferable way to go.

Three Main Advertising Categories. If you look at the ads in magazines, you'll see that most advertising photography falls into one of these three categories:

1. *Illustration*, which includes what I call "people" illustrations and "people using products"
2. *Fashion and Beauty*, which includes clothes, accessories, cosmetics, and hair products
3. *Still Life* and/or *Food*, which includes products of every kind and all types of food, both cooked and uncooked

Most art directors think in terms of one of these specialties when they start to develop an ad. Likewise, if you are looking for a rep, he or she may also want to categorize your work along the same lines. For a long time, reps preferred not to work with more than one photographer with the same specialty, on the theory that similarity of style would present a conflict. These days though, this is considered less important, since it is acknowledged that each photographer has a particular style or range to offer and thus will make a separate contribution.

The Illustrator. If you do illustration you may photograph a wide range of subjects, from architecture and landscapes to scientific, medical, and high-tech subjects, as well as people pictures.

Visualize a few examples of people and people-with-products illustration: an insurance ad showing an enthusiastic woman viewing a check issued by the insurance company in repayment for her stolen car; a close-up of a man with a headache who is about to take a dose of the advertiser's well-known pain killer; a family with their eyes happily riveted to the screen of their new color television set.

Other illustrations might include photography of less tangible concepts, such as The Salvation Army's family counseling services; a U.S. Army recruiting poster; a drug-abuse-hotline public service ad.

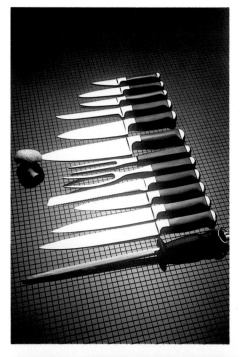

Catalog work can be a lucrative specialty if you can break into the field. Manny Akis handles high quality still-lifes in his studio, of the "table top" variety. At top left is an array of cutlery he shot for a catalog and at top right are St. Laurent's men's accessories, also shot for a catalog.
© Manny Akis

Attractive still life photographs of two much-advertised subjects: wrist watches and radios are shown here by Dan Barba.
© Dan Barba

Fashion and Beauty. Each of these fields represents a world unto its own, requiring a special kind of knowledge and approach. You can't become a successful fashion photographer by just taking an occasional fashion picture, or because you "like photographing beautiful women." It takes a mental and emotional rapport with the fashion world. The smallest difference in design, color, or hem length may change the way a fashion photographer will handle the picture.

Beauty photography is also highly specialized. Just because a photographer can shoot a pretty face does not mean he or she is a beauty photographer. Excellent lighting for skin tones is the all-important quality that clients look for, along with the ability to achieve perfection in every detail of makeup.

Both beauty and fashion photography require the use of first-class makeup artists, hair stylists, clothes and prop stylists, as well as good models. If you plan on entering this field, make sure those professionals are available in your locality.

Your markets for fashion work include: department stores, for daily newspaper advertising (usually in black and white) and for store fashion catalogs; advertising agencies that handle fashion accounts; agencies that specialize in catalog production, including both heavy-sell, volume-priced merchandise (in which quantity is more important than quality) and fine designers fashions and accessories; national fashion magazines, which offer excellent showcases for photographers' works.

Still Life and/or Food. This can be a highly profitable field, especially if you build a reputation for your work. Here too, technical expertise in lighting is a key element, along with a strong design sense and the imagination to make standard products look different and new. Still life covers the entire range of products from computer chips to refrigerators, including household goods, personal products, furniture, office equipment, typewriters, stationery, bottled goods, and industrial and electronic equipment.

These days still life photography is becoming more and more sophisticated, with innovative techniques and concepts that can make an illustration of one bar of soap, for example, look much more exciting than another.

Food is a special area. Some photographers love this area of still life work because they like food and enjoy shooting it, while others pass it by. There are more tricks of the trade in lighting and handling a foaming glass of beer or a steaming plate of pasta than the uninitiated photographer may imagine. For good food photography, you must use the services of an expert home economist or food stylist.

The Types of Advertising Agencies. The more you know about your clients, the better off you are, so it may be helpful to list some of the major types of ad agencies. Just like photographers, most agencies do overlap some services so as not to lose any business. For example, a big consumer agency may have departments devoted to industrial advertising and sales promotion.

National Consumer Agencies. These deal mainly with consumer advertising placed in national magazines read by the public. Usually with headquarters in large cities, the agencies range from the small to the gargantuan. (Once a year, the publication *Advertising Age* runs a special issue titled "U.S. Agency Income Profile" which lists agencies throughout the country with gross annual incomes ranging from a million dollars up to the billion-dollar mark. This listing will give you a good idea of which agencies to call upon if you are after major accounts as well as if you are unknown and are trying to start with smaller accounts.)

Branch Offices. The big national agencies often set up branch offices around the country to service clients' local needs. These offices can be a first-class source of top-level business. They often make their own decisions on local ad campaigns and they also generate a good deal of business from smaller advertisers in their localities.

Food photography takes a special talent. An enticing example of such talent at work is shown at left by master Tim Olive. The bread-and-butter type of food and liquor product shots are well handled below by Olive as well.
© Tim Olive

WHY ADVERTISING ART DIRECTORS WON'T USE EDITORIAL PHOTOGRAPHERS

The editorial photographer often asks: "Why don't ad agency art directors look at my portfolio? I see lots of editorial-type pictures in the ads."

The answer lies in the difference between the picture that has been made to order and the picture that has been caught at a given moment, the difference between the created and the found image. There is a world between the approach, background knowledge, and manner of execution of the photographer who handles advertising assignments and that of the photographer who may be extraordinary in candid editorial work but is not oriented to the logistics of advertising.

For example, even when a shot is to be done on location, the advertising photographer must be able to cast exactly the right model for the shot. To that end, most photographers maintain files filled with models' composites. They know at any time which child model has just lost a tooth, which model can register the real-looking emotion required, and what temperaments and degrees of cooperation the contemporary crop of superstars have. Moreover, the advertising photographer knows which locations require permits and the right telephone number to call.

The advertising photographer is in touch with the best stylists and makeup artists for each job. He or she knows which location finder to use and, for example, how to transport an entire set of props, models, and other personnel, along with lights, cameras, dressing rooms, and a portable generator to a distant beach at a moment's notice.

In addition, the advertising photographer can be relied upon to notice details that the editorial photographer might miss—that one dirty fingernail or the one slightly out-of-place prop that may ruin the shot.

The advertising photographer understands how the ad business works and how to handle expenses, billings, estimates, and cost overruns. For all these reasons, advertising art directors often refuse to look at an editorial portfolio for assignment (although they are often interested in seeing editorial-type pictures to buy from stock). As Frank Zachary, editor of *Town & Country* and a former advertising art director, says: "There is the *finder* of pictures, and there is the *maker*. Both are important."

This gleeful couple in the snow, above, may look like candid editorial shooting, but it was taken to order for a cigarette ad. © Robert Huntzinger

This photograph of a tired executive, taken for a trade ad, required a model and carefully arranged props. © Ron Sherman

Industrial Agencies. Industrial advertising is placed in trade publications (media directed to buyers and suppliers of goods and services of various trades), and its volume has been steadily increasing in recent years. Especially important is corporate institutional advertising, designed to build the image of the company. When the big conglomerates gobble up so many different kinds of businesses, they often feel the need to establish their identity all over again through advertising.

Here is an example of both the consumer advertising and industrial advertising of one company. Glidden Pigments, whose products are used by individual homeowners as well as architects and builders, might advertise in, say, *Better Homes and Gardens* to families who are about to repaint their homes—a consumer ad. They might also advertise in *Architectural Digest*, or other trade publications, to the buyers and users of bulk quantities of paint who may order thousands of gallons at one time—an industrial ad.

Independent Local Agencies. In every city or town you will find independently owned, unaffiliated agencies, many of whom do very fine work and can provide you with continuous business and good samples for your portfolio. Some of these independents handle good-sized national accounts.

Pharmaceutical Agencies. These are specialized agencies offering a good market for photographers who do people illustrations and scientific or medical photography. They have long been a lucrative source of business, and with the health craze growing so rapidly, there is a tremendous demand for photography to sell new drugs, vitamins, and other health products and equipment.

Here you show people illustrations—people looking anxious or happy, young people, old people, people looking haggard or healthy. Take a look at some of the medical magazines in your doctor's office and you'll see what's being used most.

Geographically Specialized Agencies. In Houston the oil and gas industries have given rise to agencies that specialize in petroleum advertising. In Minneapolis, where some of the world's biggest food processing companies are gathered, you'll find agencies specializing in food advertising. In Florida, there are agencies devoted mainly to resort advertising. In California, there are a number of agencies that concentrate on advertising campaigns for the Silicon Valley computer and software manufacturers. And in Los Angeles, where "the body reigns supreme," there are agencies devoted primarily to bathing suit and sportswear clients.

Collateral Material. In addition to ads, most agencies do a certain amount of sales-promotion work—booklets and brochures, mailing pieces, display cards, posters—for which no advertising space is bought in any media. The traditional payment by clients to agencies for their work is fifteen percent of what the agency spends on media space placement; these fees form, by far, the largest part of an agency's income. However, on sales-promotion materials there are no space rates involved, so the agency bills the client directly. The work is therefore called auxiliary, or subsidiary, or collateral to the agency's main work.

THE CORPORATE FIELD

Many photographers with an editorial bent and a preference for location work choose the corporate field as their primary—or single—direction in photography. Day rates in corporate work are high (nearly that of advertising photographers for the few at the top of the ladder) and, for those photographers who are able to make a place for themselves, there can be a steady flow of work. Corporations are constantly producing an enormous volume of illustrated printed material.

The plum assignment that everyone thinks of immediately is the annual report, which every corporation is required by law to produce once a year for stockholders. But there is plenty of other work that comes through in the form of brochures and booklets, mailing pieces, posters, calendars, audiovisual materials, and other sales-promotion efforts.

One complaint voiced by photographers concerning corporate work is that the field has become too crowded with newcomers. It is no longer as easy to break into as heretofore. To stand out from others now, you not only need to show a powerful, well-edited portfolio, but you must also try to build your name through advertising, mailers, and personal publicity. This is the only way to avoid that cold situation in which you are asked to "leave the book" overnight, without even a chance to show your portfolio personally.

Assignment Sources. Corporate work can come from the company headquarters or through the advertising manager, the public relations director, or an executive with a title such as "Director of Communications." Assignments can also come from ad agencies, particularly the industrial agencies, and many corporations are now turning over the annual report and other jobs to outside graphic designers. Most of these designers are located in the larger cities, although an increasing number can be found throughout the country. Some corporate photographers prefer to contact only designers for work.

The Annual Report. Enormous amounts of money are spent in the production of annual reports each year. An assignment to do an annual report represents the single largest chunk of business to be had in corporate work. An assignment may take anywhere from two to twenty or more days. At a good day rate, this can add up to a pleasant piece of change for a photographer.

People photography in annual reports. We tend to think of annual reports as being almost entirely industrial, with heavy emphasis on plants, machines, and workers. While this is true of most annual report work, there are assignments to be had by photographers who do a different type of work. If you look at any year's crop of annual reports you will see a variety of people or human-interest photography, especially in reports from banks, insurance companies, and other service organizations.

Community and philanthropic organizations stress human interest in their reports. Medical institutions may use either human interest or medical/scientific photography or both. Some companies use advertising photographers to illustrate their reports: A textile company or fashion manufacturer might employ a fashion photographer; a food processing company may use a food photographer; a broadcasting-network annual report could feature pictures of celebrities and musical or drama events.

Variety in the conglomerate report. Today's mammoth conglomerates are comprised of subsidiaries which produce a wide range of goods and services. That is one reason the people who produce their annual reports like to see variety in the portfolios they look at. They may need pictures of fifteen or twenty different subjects, from typewriters to tractors, baseball players to miners, sewing machines to jet engines.

Special annual report themes. Some companies base each of their annual reports on a special theme that is quite unlike the typical industrial coverage. Nabisco, the maker of food products including cookies and crackers, produced an annual report that became famous. The report featured colorful images of families in different countries of the world, photographed by Gary Gladstone. In another classic report, Pepsi-Cola featured photographs by Burt Glinn showing athletic teams around the world that were sponsored by Pepsi as one of its civic contributions.

A source of outstanding sample reports. Every year, The Mead Corporation sponsors a competition for the best annual reports. The judging is done by a panel of well-known graphic designers, and the winning reports are exhibited each fall at Mead's sales offices in New York. I recommend that every corporate photographer contact Mead—at their headquarters in Dayton, Ohio—to be placed on their mailing list to receive news of this event and also other valuable literature on annual reports.

Strong executive portraits are an asset to any corporate portfolio. It's a good idea to show as wide a range of styles and treatments as you can. © Gary Gladstone

41

Any time you can show how you get the company's name into a story-telling picture (rather than as a plain logo) you have an excellent shot for your corporate portfolio.
© Gary Gladstone

PRODUITS LAITIERS

Sealtest

Some companies always feature people in annual reports; others do so only occasionally. Here are families photographed in the U.S. and foreign countries for a report by Nabisco, Inc. © Gary Gladstone

The Big Brochure Market. Unless you specialize entirely in annual reports, it's a mistake to pitch your portfolio and your sales talk to clients only in this direction, because the annual report is just that, a once-a-year event. Other corporate materials are issued all the time and can constitute a regular, year-round flow of income if you go after them. I sometimes recommend that a photographer say "I do annual reports *and brochures*" when calling on a new client. You have only to look at the large number of elaborate promotional pieces you receive in the mail every month to recognize how much money goes into producing the photography that is used.

I know of a photographer with a gross yearly billing of a quarter of a million dollars who does nothing but produce brochures for several food and home-products companies. And another photographer, by showing a lively, people portfolio to a pharmaceutical company, obtained a profitable two-month assignment for a brochure that involved traveling across the country photographing healthy, cheerful people who had benefited from taking the company's new line of vitamins.

Brochures cover every conceivable subject. Some photographers make their entire living doing recruiting brochures

Pattern shots are extremely important in a corporate portfolio. Silhouettes, although not to be overdone, are effective also.
© Gary Gladstone

showing how people enjoy working for a company. For example, a brochure might show a salesman for a textile mill in South Carolina going about his job during the day and swimming in his own outdoor pool after work. Or the photographs might show a stewardess of a national airline attending a training session, then at work on a jet, and then enjoying her leisure hours in an exciting nightspot. Another popular brochure type is the so-called capability brochure; it illustrates with photographs and text a company's facilities or services in an effort to promote new business.

Corporate House Publications. House publications are magazines of varying size and circulation, published by the companies themselves. They range in circulation from a few hundred to five million readers, depending on whether they are directed only to employees, or to a network of suppliers, buyers, and other sources, or to the public at large. (A major source of information on house publications is the *Gebbie House Magazine Directory* published by the National Research Bureau, Inc., in Burlington, Iowa. The volumes are expensive, but most libraries will have the current edition available for reference.)

Smaller or medium-sized publications, while not very high-paying markets, can provide life-saving assignments for photographers who need to

Four good subjects for the corporate portfolio: the large industrial installation, exterior (far left); the large industrial installation, interior (top, left); pictures involving transportation (left); and the aerial view.
© Gary Gladstone

Fine hi-tech pictures like these require practiced skill in order to control the lighting on the elements you want to show in each image. All: © William Rivelli

Two fine editorial photographs are shown on the facing page. Top: A now-famous shot of a runner at the end of a marathon race. © Chuck Rogers. Bottom: A moving image showing the mourning vigil for John Lennon after he was shot. Thousands gathered in Central Park in New York. © Ken Sherman

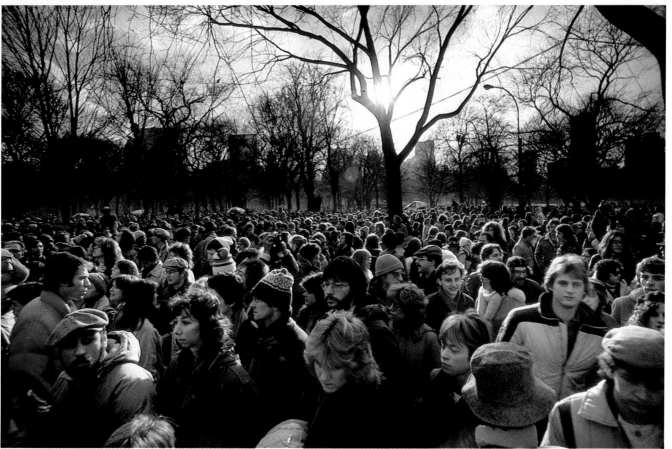

augment their incomes or those who are just starting out. The larger ones, such as those published by the Exxon Corporation and by Touche Ross & Co. (one of the country's largest accounting and management companies) are of the quality of a national magazine and use first-rate photographic talent.

THE EDITORIAL FIELD

The editorial field is less clearly defined than advertising or corporate work for a number of reasons. It involves a huge number of diverse publications, as well as an enormous range of types of assignment work. It affords lower day rates than the other two fields, with the result that comparatively few photographers do editorial work exclusively. Most supplement their income by other means. Many photographers who do some editiorial assignments are generalists, doing corporate and advertising and public relations work as well.

We tend to think of editorial photogra-

phy as being entirely photojournalistic. However, there are fashion and beauty illustrators, with and without studios, who work regularly for magazines and find such publication a valuable showcase that helps them increase their advertising business, or get a start in it. There are other types of specialists doing both advertising and editorial work; the architectural photographer, for example, who does exteriors and interiors of homes. Both types of photographers get considerably higher fees than most photojournalists.

There can be a great deal of satisfaction in photojournalism. Unlike the situation in advertising and corporate photography, you get credit lines. There is adventure, more free wheeling, and a certain amount of glamour in assignments—working with celebrities, travelling around the country or the world, and digging into interesting and sometimes important stories. However, only a few photojournalists have been able to de-

Two familiar faces: John Huston and Katharine Hepburn, photographed for editorial use.
© John Bryson

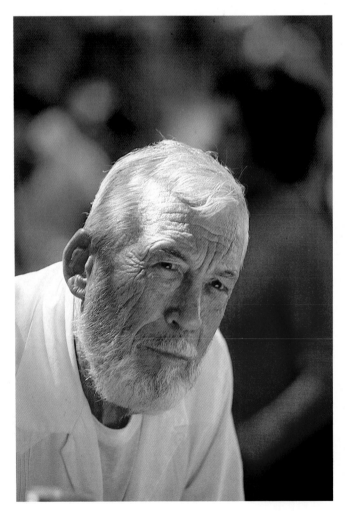
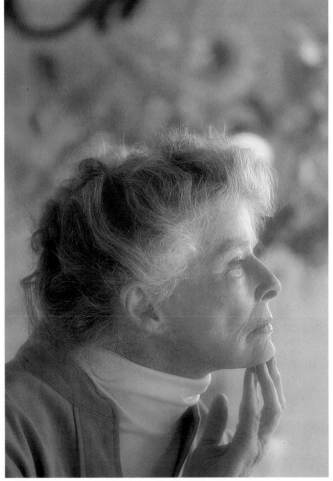

velop the major outlets, foreign resales, and syndication necessary to keep themselves well paid enough to remain purely editorial. Eddie Adams, formerly a special correspondent for the Associated Press, and a contract photographer with *Time* magazine comes to mind as one of the outstanding survivors. In addition to his work with *Time*, he freelances with various magazines. And John Bryson, who covers travel and political stories for *Life* magazine and other publications, as well as the movie industry and Hollywood's biggest stars, should also be considered in that small group of superstar editorial photographers.

Stock sales now amplify editorial incomes. Most photographers doing editorial work these days are generalists, doing assignments in the advertising and corporate fields as well. However there are some photographers who have built up very large stock files, which they keep in-house or with a stock agency. This is a comparatively recent development; their stock sales amplify their incomes so well that they now make excellent livings, and the money from stock sales permits them to take trips and do stories on their own, which in turn produces new stock material.

Fewer general magazines, more specialized publications. More specialized publications are introduced each year, covering every conveivable subject. You can find magazines on the stands that report on women's fashions, men's fashions, women executives, wealth, health, vegetarianism, investing, gambling, house building, gourmet cooking, child rearing, guitar playing, auto racing, and surfboarding, to name a few.

TYPES OF PUBLICATIONS

The following is a partial list of the main types of publications using freelance photographers.

General magazines. There aren't too many left; *Life* magazine and a few others make up the entire field.

Special interest large consumer magazines. These include *Omni, Geo, National Geo-graphic*, and the Time-Life group: *People, Money, Discover, Sports Illustrated*.

Major news magazines. Time and *Newsweek.*

Business magazines. Fortune, Business Week, Forbes, U.S. News and World Report.

Professional publications. These include such publications as the medical magazines subscribed by doctors and dentists. They cover a surprisingly wide list of consumer-oriented subjects such as vacations, how to handle money, and family concerns.

Sports magazines. Every sport has its own publication. These magazines pay little, and buy a great deal from stock.

Women's magazines. The national women's magazines use a great many fashion and beauty photographs. They also use high-level photojournalists. *McCall's, Ladies' Home Journal, Woman's Day, Redbook*, and *Family Circle* are the leaders.

Shelter publications. These are the magazines using architectural freelancers for photography of exteriors and interiors of homes.

Regional and local magazines. New York magazine set the pace, and now many cities and regions across the country have their own publications devoted to local issues and ideas. Most of these use a fair amount of photography, but like all publications, they are besieged with photographers.

Sunday newspaper supplements. These are sources for assignment for photography as well as for the purchasing of self-generated stories.

Other specialized magazines are proliferating month by month. A prime example is *Modern Maturity*, one of the leading publications devoted to the senior citizen.

OTHER PUBLICATIONS

Newspapers and wire services. Both sometimes assign local photographers to cover news stories or shoot feature pictures, outside their own staff.

Weekly newspapers. A photographer who is just starting out can build samples by suggesting ideas or by completing self-assignments. This market pays extremely little and is less damanding than larger publications, hence it is more accessible.

Trade publications. Practically every industry and trade association has one or more magazines devoted to the problems and news in that particular field. Most of these pay very modest rates.

Travel. While competition is fierce in the few magazines devoted to travel, most magazines use occasional travel pictures and feature stories. The major airlines all publish their own in-flight magazines.

THE DEDICATED PHOTOJOURNALIST

For certain freelance photojournalists who are experienced, photojournalistically excellent, and capable of generating their own ideas, the new wave of syndication agencies can be a great boon. These agencies are highly geared to resell feature stories, personality stories, and news stories abroad, after first selling them in the United States. Certain photographers who produce enough salable work over a period of time may be assisted in executing a major story by the agency. These agencies include Sygma, Gamma-Liaison, Contact, and Cipa.

Try for Covers. One profitable aspect of editorial photography is often neglected by photographers when undertaking a job of any importance: getting assigned to do a cover shot. When I worked with magazines on an assignment for a photographer, I would usually ask if there was a possibility for the magazine to run a picture on the cover. Sometimes the editor, who hadn't thought about it, would reply, "Well, there may be. Shoot for one anyway." It will pay you to keep cover possibilities constantly in mind, and push them wherever you can.

DON'T CONFUSE PUBLIC RELATIONS WITH PUBLICITY PHOTOGRAPHY

Often when I suggest to an editorial or corporate photographer that a good market to expand into might be public relations, the response is: "Oh, no, I don't do publicity work." But let me tell you: The difference between public relations photography and a publicity job is about the same as the difference between a first-class feature film and a B movie.

Publicity pictures command low fees. Publicity pictures are the quickie handshake shot of the mayor greeting a visiting dignitary or a celebrity breaking a bottle of champagne over the bow of a new ship. You can't—nor does anyone expect you to—do more than get a fast shot of the occasion. You can't ask the mayor to move over, and you can't ask the champagne wielder to wait a minute until the sun comes out. The client wants only a record, not a masterpiece. That's all right if you want that kind of work, but don't confuse it with the more cultivated art of public relations photography.

Public relations photography, when assigned by a good public relations firm, may call for the best of photojournalism. Here is an example of public relations photography at the highest level: When I was representing W. Eugene Smith, we had a call from a public relations firm that was embarking on a ten-million-dollar fund-raising campaign for The Hospital for Special Surgery in New York. They wanted a photographer of Gene's stature to do a set of pictures on the leading doctors at the hospital, the treatments given to the hospital's orthopedic patients, and the uniquely sensitive way in which the hospital's corps of psychiatric social workers helped both patients and families deal with health-related trauma. The photographs were to be used in what is known as a cocktail-table book, which was to be presented to the hospital's largest fund donors. The fee was $14,000, and Gene could take as long or short a time as he wished to, to shoot the job. A nice assignment, right?

Gene took the job, and he enjoyed every minute of it. That was a rare assignment for an extraordinary photographer, but it tells you how high a level first-rate public relations photography can reach.

*P.R. helped ex-*Life *staffers.* When the weekly version of *Life* magazine folded some years ago, many of the staffers and the national network of photographers

who worked regularly for the publication were left high and dry. They needed to search out new work, and it was public relations, the next logical step for an editorial photographer, that saved the day for many of the *Life* pros.

From one picture to many. Public relations assignments can range from single pictures to picture stories for release to magazines, newspapers, and wire services. The assignments can range from spending a day with a pop singer to making a portrait of the chairman of the board of a large corporation. The work can involve a five-picture story on a man who survived cancer, done for the American Cancer Society; a five-day assignment for an Ivy League college; or a week shooting a picture story on a new resort in the Caribbean. Basically, the client is paying you to do an editorial piece that promotes a service, idea, or product.

Thousands of Potential Clients. To give you an idea of how wide a market exists in public relations, let me tell you that every organization of any size throughout the country maintains a public relations department—and this is besides the hundreds of independent public relations agencies that exist. If you look in your telephone directory for these opening nomenclatures: Association of, National Association of, International Association of, you will find many headquarters for trade associations that are potential clients. Institutions of all kinds, from hospitals to centers of aid for special groups such as the handicapped, the young, and the elderly, to mention a few, use photography as part of their fund-raising programs.

Organizations such as the Boy Scouts, the Girl Scouts, and the Campfire Girls use photography. It is impossible to list here all of the institutions, organizations, and associations that are markets open to public relations photography; many of these maintain a headquarters in a major city and branch units throughout the country or the world.

As to what they pay, I can only say that small organizations do not pay well; you must seek out the larger ones, and these, while paying less than advertising or corporate work, are quite adequate.

Public relations agencies. If you are interested in learning more about public relations, an excellent list of public relations firms, including a breakdown of their specialties according to subject and geographic location, is published under the title *O'Dwyer's Directory of Public Relations Firms* (J. R. O'Dwyer Co., 271 Madison Ave., New York, NY 10016). A similar directory covering corporate communications is also published by the same company.

Public relations pictures: In this photograph, taken for the Girl Scouts of the U.S.A., the photographer has taken the time and care to produce a quality image. Photo: Courtesy the Girl Scouts of the U.S.A.

Publicity picture: The classic hand-shaking shot, taken at a Nobel Prize ceremony by a photographer from United Press International. Photo UPI/Bettman

51

UNDERSTANDING HOW YOUR CLIENTS THINK

Having a basic understanding of the mentality of your client is just as important as knowing your direction and your markets. What makes them tick? How do they operate? What are their problems? If you try to understand what a client wants and then fill your portfolio with images that will solve that client's problems, you will be off to a good start.

Unfortunately, many unseasoned photographers regard art directors as incomprehensible creatures with inscrutable reasoning. Established photographers usually have a fairly direct understanding of a client's mentality, but beginners tend to see clients as an unknown quantity, intimidating and possessed of a mystical power to say yes or no. This attitude doesn't help you to think very creatively when working on your portfolio.

I have often heard photographers say: "You never can tell what a client will want. I show them something I think they'll be crazy about and they pass it by without a word. Then they love something I think is way off the mark. There is no way to outguess them." But there's much more to it than that. It's true that we can't know in advance all the thinking that influences a client's decisions and that every client has his or her own predilections and prejudices. But by and large, there's a lot we *can* know to guide us, and beyond that, it is possible—and necessary—to understand clients. You must grasp their needs and problems and prepare a portfolio that will go over well with a majority of them.

ART DIRECTORS ARE JUST LIKE US

Don't be intimidated by important art directors. True, they do wield power and their yes can mean a lot of money to you, but they are human, just like the rest of us. Whenever you become intimidated by an art director, remember that they have the same concerns as everybody else: trying to make a living, trying to make more money, trying to create a rep-

utation, trying to move ahead, trying to do what they most want to do.

The Psychology of Clients. Every client that looks at your work asks himself or herself three things. First, "Can I use the kind of pictures I'm seeing?" Second, "Do they offer me something better or different than what I'm getting now?" And third, "Do I have anything in the works now, or coming up in the future, for which I might want to hire this photographer?" When an advertising A.D. goes through your portfolio, he or she is keeping their clients in mind and thinking of which images in your portfolio will fit those clients' needs. If you are showing your work to a picture editor of a magazine, a similar thinking goes on: "What articles do I have scheduled? What's coming up next? Does this photographer offer me anything different or new."

Clients want to be sure of what they're getting. There is so much insecurity and tension among art directors and editors today that they need to be able to see in your work that you can be depended upon to deliver a job. If you are given a small assignment and it doesn't work out, the A.D. doesn't want the bother of redoing it, to say nothing of the complications of settling who pays for what part of the reshoot fees and expenses. If it is an important job, the A.D. just can't afford to take a chance. That's one reason why, then times are bad, the photographers with the biggest reputations continue to sell. This makes it hard for young photographers with limited samples. I don't know any answer to this except to show your best work and start with smaller clients who will give you an opportunity. Then gradually work your way up.

Clients want to use work that will make them look good. Any photographer with something to offer who can help an art director win pats on the back

52

from "upstairs" will find the welcome mat always out. I have seen newcomers with great talent (or a special flair) and the technique to back it up, move ahead quite rapidly.

What clients have on their minds besides your portfolio: meetings, problems with the boss, deadlines, bills the front office won't okay for payment, fouled-up art work, personal problems, what to have for lunch. That's why you sometimes have a hard time getting their sole attention for the presentation of your portfolio.

Do Your Homework. When a photographer goes into an interview with some knowledge of a client's problems and needs and can show how photography can prove helpful, the photographer immediately puts himself on a level that the client respects. Don't make a portfolio call without having some idea of what the client is interested in. This doesn't mean that you should hand-tailor your portfolio to each person you see, but it does mean that you should at least know enough about the client's business to be able to judge whether your pictures are on the mark.

YOUR ADVERTISING CLIENT

Every successful advertising photographer has to be an ad-watcher. You must scan the pages in magazines and keep current with the graphic-arts publications that feature the latest ads and the agencies, art directors, advertisers, and photographers involved. Publications such as *Print, Art Direction, ADS,* and *Communication Arts* are all worth subscribing to in order to keep up with what's happening in your field and what should be shown in your portfolio. *Advertising Age* gives essential industry news and information, as does *Ad Week* and various regional publications.

If you read these magazines, you will often see an article about an art director that will tell you more about his or her personality than you will learn from any other kind of investigating. For example, I once clipped for my files a personality profile in *Art Direction* written about an art director I was planning to call upon. The piece quoted the A.D. as saying,

"My feeling about advertising is like that of an expectant father. Not that I'm nervous, I'm just anxious to see the end results." He went on to say, "Advertising isn't for sensitive people. You can't be vulnerable. You can't think of your layouts as sacred, you always have to be ready to do another one."

Until I read that interview, I hadn't known the personal attitudes and characteristics of this man. Reading the article made it possible for me to have a more interesting conversation with him when we met. I was also able to work more closely with him later because I understood more about the way he thought.

Another good way for an advertising photographer to keep up with trends is to scan the picture spreads in some of the avant-garde European magazines that run the work of the leading photographers from around the world.

YOUR CORPORATE CLIENT

Here, the clients you deal with are mostly corporations or graphic designers and some ad agencies. Look at as many good annual reports and brochures as you can lay your hands on. If you plan to see a very important potential client, it won't hurt to write or call for a copy of their current annual report.

A good source for copies of annual reports is the list made available by The *New York Times.* In March of each year, the *Times* runs a full-page ad listing dozens of companies that offer their reports to the public, with a coupon that can be checked off for each report requested. *Business Week* also offers this service and I usually make a blanket request to receive as many reports as I can get. I also recommend that you arrange to be placed on the mailing list of the Mead Corporation, as I mentioned earlier.

For detailed information on the various products a company may be involved in, there is the *Standard Directory of Advertisers,* published by the National Register Publishing Co. Since so many corporations have now merged with other companies to form conglomerates, this directory will help you keep up with who is making what. You might be surprised to learn that General Mills owns Eddie Bauer, the outdoor clothing sup-

plier; or that Warner Communications owns the Franklin Mint, producers of limited edition coins.

Read the business news. I also find it helpful to read articles and interviews in trade publications, especially those run in the advertising and business sections of local newspapers and regional magazines. You can't spend all your time reading, but here and there you will learn about art directors and corporations and their philosophies and interests. All this information will help enormously in making a personal connection with somebody you have read about and then meet in person.

The stories of what companies are doing—the battles to take over competitors or to capture a share of a market—often read like suspense novels. It is also helpful to scan publications for news about major business personalities such as a board chairman or a chief operating officer. All this makes for good conversation when you have a chance to talk with a client. Besides, if you read that a head of a company believes in strong sales promotion or is expanding a division and wants the world to know about it, you can bet your bottom dollar that more photographic work will be forthcoming from that company, and it's time to show your portfolio.

Here is an instance where reading the business news paid off. A few years ago I read in an advertising column that J. Walter Thompson, the giant agency, had set up a new department solely to handle one aspect of their clients' needs: corporate advertising. The head of the division said something that caught my notice. "Corporate advertising in the eighties," he stated, "could be as important as brand and product advertising was in the sixties and seventies." The new trend toward conglomerates and multidivisional, multinational corporations, he said, had made it essential to establish a corporate identity. From then on there would be vastly more "identity" ads, designed to win public favor. This article alerted me to a new trend. Soon I was reading other stories about the mushrooming corporate advertising business, and I was able to steer my corporate photographer clients in that direction.

YOUR EDITORIAL CLIENT

The most common complaint of picture editors is that photographers come in to show portfolios without having bothered to study the magazine sufficiently beforehand. It seems pretty obvious to me that it is merely common courtesy—if nothing else—to know something about a publication before you ask to work for it. More than once I have heard an angered picture editor complain: "This photographer brought in his portfolio without the slightest idea of what our magazine is like or the kind of stories we run. His work was not of the type we need. And then, after wasting my time, he had the nerve to expect me to do a critique of his work!" If you're not interested in the magazine, why should the magazine be interested in you?

Look at back issues. It isn't enough to look over a current issue of the magazine you want to contact for the first time. In order to familiarize yourself with the publication's general tone you need to see several issues. The magazine might favor certain subjects that are not included, for some reason, in a current issue. Or the editors may have handled a certain story in the past in a style that you consider one of your specialties. You can always see back issues at the library or buy them from the stores that specialize in the resale of old magazines.

Best of all, study one magazine for which you are interested in working, issue by issue. When you see something published in the magazine that would have been right up your alley, make a note of it. Then, when you are calling on the picture editor, be sure to point out, "That story is just the kind of thing I love to do," or "I do that especially well," or "I am moving strongly into that area. Would you keep me in mind if something like that comes up again?" Editors don't always think of you when you want them to.

When you know what kind of articles the magazine is using, you can think about which pictures you would like to be assigned to do yourself. Often you can suggest this, if you say it in such a way that it doesn't seem too aggressive. Said correctly, you can clearly show that you are interested and want to be helpful.

IN PHOTOGRAPHY, "SELLING" ISN'T SELLING

The best way to sell yourself to your clients is to be really interested in whatever problems they have and to be eager to help solve those problems. The first rule of selling is to "wear the client's hat": to *empathize* with his or her situation. Every successful photographer and rep who is good at dealing with clients knows this principle and uses it.

Sales calls in photography do not require aggressive selling in the usual sense of the word. You don't have to be a salesperson because what you are really offering is a service. In photography, smart selling is the art of letting your client know you want to—and can—be of service. "Slick" salesmanship rarely works.

What will help you sell yourself best is not to have a glib tongue but to fulfill these requirements:

- Put your portfolio together in such a way that the client can understand quickly what it is you have to offer

- Make your presentation as interesting and strong as possible

- Use forethought to present material that will be interesting to your client

- Demonstrate in every way you can that you have a "feel" for your client's problems

Emphasize the idea of contribution. I learned early on when I was a rep, that it was much more important to talk about what a photographer's capabilities could do for the client than to talk about the capabilities alone. In other words, to remember that every client was more interested in himself or herself than in my photographer. I would say, for example, "I think so-and-so's strong design sense (or ability to demonstrate a concept, or to use dramatic colors, or whatever) can make a real contribution to the such-and-such advertising campaign."

If you are selling yourself, you may not be able to use this kind of talk so easily, but if you remember the idea of making a *contribution*, this will help you put it nicely.

The "You" Attitude. When I once worked briefly as a fashion copywriter, it was a rule of our advertising manager that you could never write a piece of copy that didn't start with the word *you*—and *you* would have to run all the way through the copy as well. My copy would have to start, for example, with: "You'll like wearing this suit when it's hot outside" or "You'll look twice as pretty wearing this makeup."

"Rule #1—Use the 'You' Attitude" was the maxim printed on a card hung on the office wall. I tell this story because the rule I learned then has been the rule I've observed ever since, especially as a photographer's rep dealing with clients. While you may be showing *your* work, *your* style, and *your* subjects, you should be most concerned about *your client* and what your creative talents can do for him or her. (In case you are questioning this approach, there is nothing phony about being sincerely interested in being of service to your client, of having his or her interests at heart as well as your own. After all, isn't that how the best relationships in life, as well as in business, are built?)

Visualize Your Major Clients. Don't let clients be dim shapes in your mind. When you are selecting pictures for your portfolio, try to visualize the people who will be looking at them. Think of the editors or art directors from whom you would like to get work. Take one typical client. How will he or she react to this or that sample? This may sound a bit esoteric, but it helps you to keep in contact with what you're doing.

As I select pictures for a corporate portfolio, for example, I may be seeing in my mind's eye the public relations director of Union Carbide or Standard Oil, and I ask myself how he or she would react to my choices. Or, when I am having trouble deciding between two images, I may think of a very good graphic designer, and I try to visualize how he or she would judge the two pictures, either for quality or relevance. I don't abide necessarily by any one person's judgment. What this mental visualization does, however, is give me a sense of *distance*, so that I can see the images I am working with more objectively.

WHAT YOU SHOW IS WHAT YOU GET

Do you want to upgrade your price structure? reach higher levels of the market? realize a better percentage of success in actually clinching the jobs you go after? do more creative work? introduce another subject area or style to your portfolio and to your work?

There is really only one way to handle these problems. You need to spend the time to produce, under your own steam, new portfolio samples that will impress clients and influence them to use you for the kind of work you want to do. Because the kind of work you show in your portfolio is the kind of work you're bound to get. It's a simple Q.E.D. proposition—a matter of stimulus and response.

YOU CAN'T "TALK" PICTURES

It is a fact of life in selling that you can't show one type or level of work and tell your client that you want to do something else. You can't rely on clients to use their imagination on your behalf. In fact, there is a saying among reps that if a client has a job calling for pictures of red apples, you have to show him red apples—he won't assign you the job if you show him *green apples*. Whether this is because art directors are busier these days, or more insecure, or both, I'm not sure, but the reality is that A.D.s go only by what they see.

The vicious circle. If you show mediocre pictures you get mediocre jobs. The mediocre jobs produce mediocre samples that add nothing to your portfolio. The worst aspect of this is that you get locked into a category with the clients to whom you show your work.

MAKE SELF-ASSIGNMENTS

It isn't easy to make self-assigned photographs when day-to-day work keeps you busy, but unless you are getting all the work you want, *of the kind you want*, I don't know of any other way to stay ahead of the game. Most top-flight advertising photographers, to be sure, are constantly testing models and setups and producing new samples, but many

This handsome hi-tech image by William Rivelli is bound to impress a client with the photographer's skill and artistry and will no doubt produce more work of this kind.
© William Rivelli

photographers, especially those who don't work in advertising, do much too little self-assigned work. Here are a couple of ways to make it easier on yourself.

Give yourself time. Don't let yourself feel pressured to get quick results. Don't expect to get a great sample every time you shoot. Accept the fact that not every idea will work out.

If you want to produce a new portfolio, it's better to allow as much time as you need to build it than to let yourself feel so intimidated by the idea of getting it done quickly that you never even start.

Don't do snapshooting—aiming the camera at everything you see when shooting outdoors. Instead, try to find one good picture possibility and spend half of a day or more working on the best possible shots. Put lots of thought into each concept. It's better to aim at getting one fine picture over a period of days or weeks than to get dozens of ordinary photographs that you surely don't need.

Don't get too ambitious. This is important. By all means, avoid tackling subjects that are too difficult for you to execute superbly, or too big and complicated to handle with the resources at your disposal. I know a photographer, for example, with a small studio who continually undertakes extremely complicated illustrations. His ideas require many models and big sets, but he can't afford the best models, stylists, or set builders to do the job properly. The result is that he ends up with no new samples. This pattern of self-improvement is actually self-destructive.

How to Get Ideas for Self-Assignments. Many photographers find it hard to develop their own ideas for pictures. In an effort to discipline themselves into "doing something," they may strike out blindly, without thinking through an idea or deciding on the point they want to make with the picture. Then they find themselves discouraged by the poor images they produce.

The main point to keep in mind is to work on subjects that interest you, and from that, ideas will flow. This rule is the basis for my entire approach to photographers and their

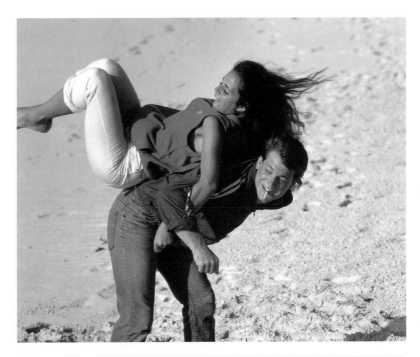

Advertising illustrator Nancy Brown loves to photograph young, healthy, carefree young people in all types of leisure fun, and is known for her gift with this type of shot.
© Nancy Brown

work, and it has proven to be the best piece of advice I can give. If you are a high-tech person, do some high-tech pictures. If you are a sports fan, work on sports pictures. If you like doing things with your family, consider photographing the activities that make good people pictures (but you don't necessarily need to photograph members of your own family unless they are extremely photogenic.)

Howard Chapnick, president of Black Star Publishing Co., suggested in a column he wrote a few years ago for *Popular Photography*, that photographers could benefit by giving themselves a word or an idea to explore photographically. How would you translate concepts like "beauty," "efficiency," "speed," or "luxury" into visual images?

People pictures. Although Guy Gillette does much corporate and industrial work he still enjoys working with people and he shows pictures in his portfolio that reveal his warm, human touch.
© Guy Gillette

You may find it useful to return to Chapter Three, "How to Clarify Your Direction," for clues to what you should be photographing. Here are a few more specific suggestions.

Make a file of clippings from ads or article illustrations you find in magazines, picking photographs that you would like to have in your portfolio. Then, on your own, produce your versions of those illustrations (but don't just copy them).

Read the headlines on a batch of ads or articles and cover up the accompanying illustrations with your hand. Then ask yourself, "How would I illustrate this headline?" Compare your visualization with the one that was used. This is one of the best ways of getting used to interpreting ideas and dealing with clients' concepts. Also, by comparing your visual interpretation with what was used, you can see which of your ideas really work and which are too vague or weak.

Build up a body of work with pictures on themes you discover you like best. Don't just do one or two pictures of this kind, but go deeper into the subject. You may find yourself developing important minispecialties that will help you get new business and, at the very least, broaden your range.

Avoid showing two ideas in one picture. You may get so caught up in a new concept that you fail to focus on the main theme of the shot. For example, a photographer in Los Angeles who was shooting an automobile wanted to show the car's "luxury, beauty, and technology." He was so absorbed in trying to capture both the lushness of the elegant upholstery and the wizardry of the dashboard instruments that he ended by emphasizing neither. Even worse, he failed to notice the dust that was sorely visible between the creases of the seat covering.

SUBJECTS YOU LIKE CAN ALSO BE SALABLE

Doing your own thing can be very practical in terms of producing salable samples for your portfolio. You might start by making a list of the subjects or ac-

tivities you enjoy. This list will help generate ideas for pictures. To find out how good your ideas are, ask the following two questions. First, "Which potential advertisers or publications might find these illustrations of interest?" Second, "Do I need to fill in weak spots in my portfolio with these kinds of subjects?" Here are just a few examples of the ways this approach can work in your field.

Advertising Samples. Let's say you feel like shooting an automobile and have an idea of the images you want to produce. Besides automobile manufacturers, which other clients might be interested in seeing this type of shot? It goes without saying that a picture of a car on a scenic western highway will be of interest to gasoline companies. And a spark plug manufacturer might want a dramatic shot of a racing car for advertising use. A long list of possible advertisers can make your automobile shots important as portfolio samples. Makers of lubricating oil, car polish, tires, seat covers, car stereos, and auto burglar alarms, among others, might be interested in seeing your automotive photographs.

Corporate Samples. One of the weak spots in many corporate portfolios is executive portraiture, and self-assignments can help you fill in this important area. You are probably saying, "I can't get the chance to photograph an executive without an assignment." While this is usually true, I am suggesting that a little resourcefulness can be used to get the samples you want.

You must have friends and relatives who *look* like business executives, even if they aren't and you should be able to photograph them. You can usually find a desk or a corner of a bookcase that is a suitable background, or use another friend's office.

Other weak spots in corporate portfolios include images of workers at machines and shots of construction in progress. One way to get industrial locations for your sample shots is to find a small manufacturing company that will let you take pictures in their plant in return for a free picture or two. You might bring along your own "worker." And you can usually find construction shots just by

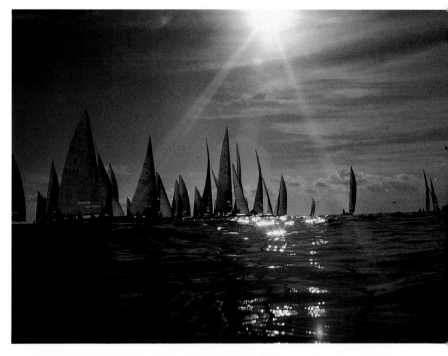

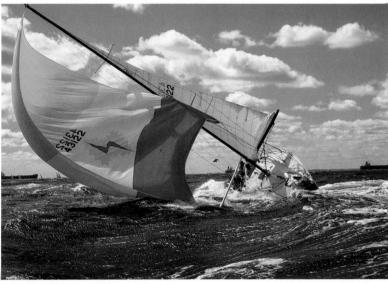

walking around the streets and photographing what you see.

Editorial Samples. Here, the world is your oyster. Pick any area in which your portfolio needs more good images, from travel to documentary, from a personality portrait to action pictures of a rock star. You then need to judge whether the subjects you want to shoot are of interest to the markets you are aiming at with your portfolio. This means taking time to honestly and objectively check the publications you are interested in, to make sure your samples are on the right track.

If you are a a serious photojournalist, I strongly recommend that you do a story

If you like sailing, why not show sail boats of all kinds, from small to large in all kinds of weather? Here, two typical sailboat shots by Bob Dollard.
© Bob Dollard

AL SATTERWHITE. ELEUTHERA, BAHAMAS. OCTOBER 1980 ISSUE.

"Increased means and increased leisure
are the two civilizers of man."
—Benjamin Disraeli

We create civilized dreams for the men
and women who possess all the resources to
make them happen.
Because we are

Three attractive travel scenes by Al Satterwhite as they are used in ads. © Al Satterwhite

in depth, researching and shooting it on your own, and presenting it as a finished product. Many photojournalists have seen their careers leap ahead by using this approach. For example, Danny Lyon's powerful essay on prison life made a great impact on editors and helped establish him as a first-rank photojournalist. However, don't try to do a major story if you are just starting. Wait until you have had some experience and can handle a significant subject.

For any editorial portfolio, it's always a good idea to include, together with single pictures, a set of eight to ten related pictures in story form to show how you would handle an assignment.

Samples, Samples, Samples. I can't overemphasize how important it is to continually, and above all else, think about building up a stock of good samples for your portfolio. When you get an assignment, ask yourself, "Will this job provide a good sample?" Not many photographers are in a position to turn down assignments if the jobs won't provide good samples, but that question should be part of your consideration of every job offer.

Again, your portfolio is your main selling vehicle. If the samples aren't good, you can't hope to get into the better markets. If your samples aren't good, you can't expect to command higher fees. If your samples aren't good, you can't build a reputation. The samples in your portfolio bring in the money you put into the bank at the end of a good year.

How Pete Turner worked toward samples. During the first three years I repped Pete Turner, we agreed that we were building for the future and we would therefore make great samples our first objective. I still remember the decision we had to make when we were offered two different jobs, both for the same time slot. One paid $750 more than the other, but we knew that the lower paying job would provide a sample that would be important to Pete's portfolio. We agreed, with very little hesitation, to accept it. The portfolio we were developing meant far more in long-term income than the $750 we were foregoing. Again, later, we turned down a $17,000 assignment from

Ford Motor Co. in favor of one that, in the end, earned $10,000. But it involved shooting a picture story built around Elizabeth Taylor at the height of her career, and it added luster to Turner's national reputation.

When you must compromise. There may be times when you must compromise by including samples of work in your portfolio in areas that you don't really want to develop in the future, because you need the income now. That's perfectly valid, as long as you're aware of why you are doing it. As soon as you can, replace samples that lead you nowhere with those that will help you grow in the direction in which you are aiming.

You may stew for years with dissatisfaction about the kind of work you are doing, and rationalize the situation with complaints like, "If I only had a better rep," or "If only I could afford to take a year off to shoot what I want," or "Clients are impossible these days." But the reality remains: The work you show in your portfolio will be the deciding factor in the kind of assignments you get.

CASE IN POINT

This is how a program for making new, self-assigned samples helped a New Jersey advertising photographer get more of the kind of work he wanted to do. As a partner in an advertising studio, he was doing well financially, booking over $350,000 a year, but he had become totally bored with the strictly nuts-and-bolts work the studio was getting. He was afraid he would completely lose interest in the business if he didn't find a way to do at least a greater percentage of creative work.

I looked over his portfolio, and from beginning to end saw nothing in it but routine product ads. I asked him how, with those images, he ever expected to influence clients who might have more creative work to be assigned. "Well," he said, "it's the old story. Which comes first, the chicken or the egg? I don't get creative work because I don't have creative work to show. I don't have creative work to show because I don't get the jobs that produce creative samples. What should I do?"

Since his studio couldn't afford to lose its current income, we decided he should continue to use the present portfolio for current clients, but that he should develop a second portfolio using new and exciting pictures, to be produced by self-assignment, to gain new clients that would let him stretch.

We talked over ideas for the new pictures. At first he couldn't think of any subjects he would like to introduce; then I asked him what he did in his off-work hours. "I like to go out on my boat," he said, "and spend time with my kids." From that answer, we had our first lead to the kind of new samples he might enjoy shooting: a series of shots connected with boats and the sea; sailboats, sunfish, motorboats, yachts; people painting and caulking boats; people dressed in sports clothes and deck shoes, enjoying life aboard their boats, sunbathing, fishing, drinking cocktails. (All these pictures, you'll note, involved products of interest to advertisers.)

We got our second lead to self-assigned pictures at the same time. Our photographer had also mentioned that he enjoyed spending time with his kids. When I asked him if he enjoyed photographing people, and children in particular, he brightened up still more. The obvious second choice for self-assignment was photographing children playing, swimming, running on the beach, building sand castles, having a picnic. The shots might be both with and without products used by children, and could include plenty of expressive head shots.

For a third self-assignment, the photographer decided he wanted to do still life shots that were handled in new and innovative ways and would highlight his talent for graphic treatment.

One of Michel Tcherev-
koff's major interests is
in the area of special
effects, which, in his
own unique way, he
handles with aesthetic
values and emotional
undertones. He calls his
effects "applied fan-
tasy": pictures like
these lend themselves
to advertising, corpo-
rate, and editorial use.
© Michel Tcherevkoff

MUST YOU SPECIALIZE TO SUCCEED?

Can you succeed as a generalist, doing various types of work? Or do you need to specialize in one of the three major fields—advertising, corporate, or editorial? Beginning photographers find this a difficult decision, and established pros are often nagged by the thought that they might do better if they broadened—or narrowed—their range.

This subject involves so many variables, so many qualifications and contradictions, that it is impossible to cover them all here, but the following discussion should aid you in your decision. If you live outside a major photographic center, for example, you may not find enough clients to support a specialty, so you must, whether you want to or not, be a generalist. On the other hand, there are specialists who are doing very well in outlying localities, especially since photographers are now doing more self-promotion—running ads and using mailers to get more out-of-town work. Sales of stock material have also increased greatly in recent years and have become an important source of income.

But this is only one aspect of the generalist-specialist question. Other deciding factors may be: your temperament, your interests, your goals; the work that's most available or comes your way in quantity; even the lucky breaks by which some careers evolve. These and more considerations are part of the problems that you must think through and balance out individually.

THE NUCLEUS OF YOUR CAREER

There is one definitive rule that applies to everyone, generalist or specialist, that is of utmost importance to your career: Every photographer must single out one area or style of work that can be emphasized and for which he or she wants to become known. This is what I call the basis of your career. Without it you can scarcely say you have a career; you may do some of this, some of that, but you will have no real roots, no security, and

no real direction. You must find one area on which to build your greatest strength, that can be depended upon for the bulk of your regular income. I can't stress this approach too much. As a consultant the first thing I do is to find the nucleus of a career.

If you are a generalist, it is obvious that you can't build a reputation and a viable business being a jack-of-all-trades. You must be known for *something*, and you must strive to be the best in your class, or you may end up not being known at all. (Having said this, I don't mean you should not also show other phases of your work; you will, of course.)

If you are a specialist, the rule applies in a different way. For example, let's say you specialize in still life. From a sales as well as a promotional viewpoint, it makes sense to single out certain subjects to emphasize. For example, are you strongest in bottled goods, household appliances, or food? Give special attention to those qualities in your portfolio.

Style is its own specialty. A personal style can constitute a specialty that transcends definite categories of work. Certain photographers, known for their unique vision, cross the boundaries of the various fields in photography.

THE GENERALIST PORTFOLIO: A TREE WITH BRANCHES

As a generalist you may work across the board, doing assignments for advertising, corporate, and editorial clients, but the proportion of work done in each area varies with the photographer. This creates a problem in producing a streamlined portfolio.

I sometimes use a rather simple analogy to solve the problem of organizing a general portfolio—with its major and minor themes—into a unified presentation.

Visualize a tree trunk with branches.

A prime example of a
successful, well-
rounded generalist is
Arthur Tilley of Atlanta,
Georgia. He works in
his studio and on loca-
tion and handles adver-
tising, corporate, and
editorial assignments.
Some pictures from his
portfolio are shown
here and on the next
two pages.
© Arthur Tilley

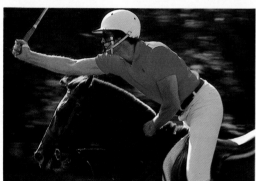

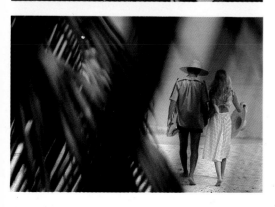

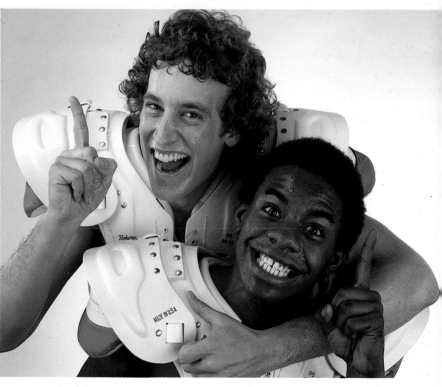

Here are more examples of Tilley's work, showing a variety of subjects skills.
© Arthur Tilley

Consider your most important material as the trunk and devote the most space to it. Consider your less important samples the branches, giving them a larger or lesser space according to their merit. (Don't have too many branches though.) In this way you convert what begins as a batch of miscellaneous subjects into a cohesive presentation.

The value of this concept lies in its functional organization. Your client is, in a sense, a shopper. I've heard one client say, "When I look at someone's portfolio, I'm shopping for what I may want. I'm not interested in a supermarket."

THE SPECIALIST PORTFOLIO: SPECIALTIES WITHIN SPECIALTIES

Even after you have decided to specialize in advertising, corporate, or editorial work, you have further decisions still to make.

In advertising (as discussed in Chapter Four) you have illustration, fashion and beauty, and still life and/or food. You may handle only one of these, or you may handle all three.

In illustration, you handle a wide variety of subjects, with special emphasis on the big category of *people* and *people with products*. This is a loose category, however, and could include practically anything from an industrial photograph to a medical one, a conceptual or storytelling picture to a testimonial portrait, or a travel scene to a man opening a refrigerator door.

As a corporate photographer your decisions on what areas to cover are fairly easy. Corporate work covers such a wide range that you can show as varied a portfolio as you want, providing you group the material correctly. You can, of course, specialize in one specific phase alone, such as high-tech or heavy-industry photographs that require elaborate lighting equipment. Most of the name photographers in corporate work show varied portfolios, though.

In editorial work, you can still specialize in an area (although far fewer photographers do so than used to), but in order to make a decent living you must do one of

Bob Bender is well
known for his specialty:
vehicles. These dra-
matic images are ex-
amples of his work.
© Bob Bender

several things: tie up with one of the newer syndicate agencies that will resell a good deal of your work abroad; go on staff with a magazine; or augment your income through stock sales.

Specialties include documentary essays, travel, geographical, and human interest stories, personalities, and sports, to name a few; also sci-fi, mountain climbing, education, and these days, sad to say, war photography.

Many Specialists Do Not Really Specialize. If the truth were told, many so-called specialists—with the exception of strict still life and food photographers—do a lot of other work besides their specialties. Few photographers can afford to turn down work; and they like to shift gears, to try many things.

Not long ago, in glancing over the lists of photographers in the membership directory of ASMP, I was surprised at the wide variety of assignment subjects many of the famous place alongside their names. Jay Maisel, for example, lists "Advertising, Annual Reports, Documentary, Industrial/Corporate, and Travel." Art Kane cites "Advertising, Illustration and General, Annual Reports, Editorial, Fashion/Beauty." Barbara Bordnick includes "Advertising Illustration, Editorial, Fashion/Beauty, Personalities, Film Commercial/Director."

IS HAND-TAILORING NECESSARY?

Sometimes yes, sometimes no. Many photographers use the same portfolio for a majority of sales calls and only make up a special portfolio when it is needed. But the trend is toward having on hand both a regular portfolio and one or more specialized portfolios.

Well-established advertising photographers usually know what campaigns are coming up and what kind of samples are required for a particular sales pitch, so they make up a special presentation. But they, also, maintain a regular portfolio. When a studio has been in business for some time, there are usually plenty of laminated tearsheets, as well as prints and transparencies organized by subject on file; putting together a tailored portfolio can therefore be accomplished quickly.

Creative Hand-Tailoring. An art director searching for an idea for a new automotive campaign asked a photographer to submit samples. The photographer put together, in 35mm color, a tray of about twenty-five slides. The samples ranged from experimental to hard-sell work: cars with and without people; cars gleaming like jewels and cars shot in fast motion; cars in romantic settings; and an especially interesting series of cooperative ads sponsored by a car manufacturer and clothes designer showing elegantly dressed models and high-priced cars in luxurious environments. It took time to pull together this selection, but the time invested paid off in a campaign for the photographer.

SOME NEW TRENDS

The trend in all fields seems to be following the lead of advertising.

Duplicate Portfolios. Advertising photographers have long made up their portfolios in duplicate, and the idea is catching on with corporate and editorial photographers. This is partly due to the fact that photographers are doing more advertising and mailings, so that more frequent requests for portfolio submissions come in, many times simultaneously. If you have only one, you can't very well send it out of town and use it for local sales calls at the same time—and why should you lose business?

Having a duplicate portfolio—or even more than two—can also solve the problem of clients asking you to leave your portfolio overnight, or for days, and leaving you with nothing to show meanwhile.

Separate Portfolios. Another trend adapted from advertising is to make up separate portfolios for each type of work. This permits you to diversify as much as you want; you simply show a specialized portfolio for each area you handle. I like this idea because it permits you to function as a generalist but look like a specialist. For example:

• A midwestern photographer working in a small city with local accounts makes a good living as a generalist. He does many kinds of work and shows

separate portfolios to retail, corporate, fashion, still life, and local resort accounts.

- A well-known New York advertising photographer who does many different things including location and studio work of a high level usually goes after specific accounts. He shows four specialized portfolios: 1) Automotive; 2) Corporate Institutional, sometimes called corporate image advertising; 3) Travel for airlines and other transportation accounts; 4) Studio Illustration.
- In Pete Turner's studio is an office with an electronically controlled viewing screen. He pushes a button and the screen comes down. Along the wall is a bookcase filled with slide-tray boxes, each containing 35mm slides that show his treatment of a subject in depth. When a client wants to see images of silverware, Pete has a tray full of many different versions and treatments of silverware. Dishes? There is a tray, with slides including table settings and individual dishes, some traditional, some modern, some showing people using dishes, others without people. There are trays for many subjects, including travel and sci-fi, as well as the graphic effects Turner is known for.

A TIP FOR BEGINNERS

A question that often comes up when you're trying to break into advertising, especially in a place like New York City, is: "Can you show more than one type of work?" The answer is emphatically no. Doors don't open easily to newcomers and when they do, it is for the A-1 specialist. The procedure is to get a foothold first with one area of strength. Then, much later, introduce your second specialty. Once an art director knows you, it won't confuse him or her or lower your appeal to be working two streets at a time.

SOME SPECIALTIES SELL IN EVERY MARKET

The powerful group portraits of Neal Slavin, the first-class, multiple motion images of Philip Leonian, and the artistically designed special effects of Michel Tcherevkoff are typical of unusual specialties suited to advertising, corporate, or editorial use.

Outside New York we find photographers like Bob Bender of Cleveland, Ohio, who specializes almost entirely in vehicles—"the entire range of automotive, truck, four-wheel drive, tire, farm and construction equipment"— for advertising and also for other uses.

His specialty has evolved from one picture used in an article about him in an Eastman Kodak magazine, which led to calls for automotive work and finally to his present stature.

In Atlanta, there is Alan McGee, whose highly successful architectural work is done for advertising, corporate, and editorial clients. Within his specialty are: "commercial and residential interiors and exteriors, home furnishings, buildings and products, with and without people."

WHAT'S THE BEST FORM OF PRESENTATION?

If you ask for advice on the best form for showing your work, you are likely to get as many different opinions as the people you see. Some prefer portfolios in small sizes, others prefer them large; some say "show only tearsheets," others vote for original color. And so it goes. The truth is, there is no absolute rule.

The form you adopt, though, will depend on a number of factors which vary with each photographer. These include the length of time you have been in the business, which dictates whether you have enough good tearsheets to show; how much you want to spend on your portfolio case, on good color prints, and other items; your personal preferences; the geographical area in which you work, which determines whether you need a specialized or a general portfolio; and above all, the markets you want to pursue, since the advertising portfolio is necessarily structured differently from the corporate portfolio, and the editorial portfolio differs from both.

Clients in each market deal with a distinctly different set of problems, and hence they are each interested in obtaining different types of information from your portfolio.

New forms of presentation are developing these days in the areas of video and telecommunications, and where these forms will lead us in the future is hard to say. However, the traditional forms are still far and away the most important for your portfolio.

APPEARANCE COUNTS—AND HOW!

Every authority agrees on one point: Clients are much influenced by the appearance of a portfolio. An attractive portfolio is a point in your favor. A sloppy portfolio is a strike against you before you even show a picture. If your carrying case is old or shopworn, on the outside or inside, do yourself a favor: Get rid of it.

Mistakes To Avoid. Remember you are in a graphic business selling your work to visually oriented people, so your portfolio must reflect a respect for, and awareness of, good graphics. Pay attention to every detail. The calling card you attach to your portfolio should be fresh and well designed; tearsheets must have clean, razor-sharp edges; color slides should *never* be shown with dust or dirt specks. Watch out for dog-eared prints or mounts, unspotted prints, scratched acetate sleeves or laminations.

One of the worst sins a photographer can commit is to show a portfolio full of mixed envelopes, folders, and boxes containing various kinds of samples. Clients do not have the time to wade through these. We have all read or heard this advice so often that I'm always surprised to see photographers (and some pretty good ones) still showing up in clients' offices with confusing portfolios of this kind. The truth is, in some cases photographers would like to integrate their material into a coherent package but simply haven't been able to analyze it sufficiently to make this possible. If this is your problem, all I can suggest is to keep trying. Try to follow the suggestions in some of the chapters in this book covering direction, markets, and editing principles.

THE ADVERTISING PORTFOLIO

What the art director wants to know is what you have to offer in the three primary areas of advertising interest: illustration, fashion/beauty, and still life/food. It requires very few images to show a photographer's capabilities in style and technique, especially since much advertising photography is shot in large format. For this reason, the advertising portfolio may contain fewer samples than portfolios in other fields.

Most photography studios maintain sets of samples in various forms: laminations, prints, and mounted color, which

73

An example of the ace-tate-sleeved book port-folio. Many photographers are using acetate sleeves with cartridge inserts instead of the spiral binding, in order to diminish the break down the middle of a spread. Photo: Studio V

can be either reproductions of ads or original transparencies. From these, special portfolios can be made up to fill specific requests. An "at-the-ready" portfolio may consist of any of these forms, depending on individual preference.

How Many Samples? There is no absolute rule. Some photographers who contact top agencies in metropolitan centers like New York City may show as few as ten strong pieces. I usually recommend showing fifteen or a few more than that, although it depends on the photographer. Outside the big centers, fifteen to twenty or more pieces may be used.

Sizes. Again, this is a matter of choice, and portfolios range from 8 × 10 to 20 × 24 inches. For laminations I prefer the 11 × 14 or 14 × 17 sizes, and for mounted color I like the 8 × 10 or 11 × 14s. There is a trend to using smaller sizes (although it may not last). It is up to the individual photographer to feel out what works best.

Carrying Case. For advertising, the most widely used case is the hardcover box of the attaché type, custom-made and handsomely fitted.

The new trunk cases. These new versions of the good old-fashioned English trunk with a handle on the top can be very attractive and efficient. They come in elegant aluminum, wood, or leather, with brass fittings, and can be slotted to hold mounted transparencies. There are also nice, flatter versions of the trunk, lined with foam rubber, which can be used to carry slide trays or mounted prints and laminates.

The new laminated accordion-folds. In this system, anywhere from twenty to fifty or more pictures are laminated and used in gatefold arrangements, in sizes from 4 × 5 to 5 × 7 inches. These too, can be attractive. However, for the most part I regard them as more of a novelty than a single, permanent portfolio, and I consider them supplementary to other types of presentation.

Video-Cassette Portfolios. I've seen some extraordinarily effective versions of this form of presentation, produced by Multiplexposures in New York, which show a number of prints or tearsheets with camera movement choreographed to music. Photographers report that these shows have been very successful in sales. They can be directed only toward large agencies that already have video setups, and then only to the creative director who can arrange a screening for a group of art directors. This type of portfolio, it must be said, by no means replaces the traditional portfolio for use day in and day out, but it rather acts as a supplement. (It's also expensive and limited, but it *is* one of the forms pointing to what may lie ahead.)

THE CORPORATE PORTFOLIO

They produce such a tremendous variety of material that the preferred portfolio form is necessarily a tray of 35mm color slides, which can readily portray the range and capabilities of a photographer.

Since corporate work runs the gamut from heavy industry to illustration and from editorial human interest to special subjects such as science or architecture, any presentation of just a few pictures in a portfolio form other than the slide tray would fail to reveal enough about what you can do. Most corporate photography buyers I have met agree with this, with a few additions. What they like to see is a diversified tray showing what the photographer likes to do, plus his or her range and technique, a run of six or eight pictures showing how an assignment was covered, and a few personal pictures that convey something about the photographer.

How Many Slides? The answer varies with the photographer. You can show a tray of forty slides, or go up to over a hundred images. The tendency, though, is to reduce the number of slides shown. Many trays are now limited to a carefully selected fifty to sixty-five slides, plus a few strong tearsheets of published work. But don't let yourself be too influenced by what others do.

For the advertising portfolio, the preferred carrying case is the box, which can hold laminated tear sheets, prints, and mounted transparencies. Try to keep laminated samples in one size when possible, and handle them carefully. Portfolio case courtesy Spink and Gaborc/Photo: Studio V

If you have a large variety of "great" work, follow this maxim: "If you've got it, flaunt it." If your best pattern shots are different enough, show them. Don't cull down your most powerful executive portrait group to the point where you dilute its strength. Corporate buyers will always be interested in seeing a good range of exceptional work.

On the other hand, if you are new to the field and have only a few good images, try to cut your presentation to the bone.

Other Forms of Presentation. It is very helpful to have an acetate-sleeved book containing tearsheets and prints to show with your tray when time permits, or to show separately when you can't project slides. Tearsheets, if you have them, are especially important to establish credibility when you are relatively new and unknown; in fact, they are always effective—providing you have good ones.

The average number of samples in a flat portfolio of this kind is usually held to twenty pages or so, which, counting both sides, gives you up to forty pieces. It all depends on how good the material is; the book can be impressive or a total bore, as you know.

Laminations. Some photographers prefer to have their tearsheets laminated and carried in a rigid box-type portfolio. Again, this depends on what you have to show. I have often seen corporate photographers start with a sleeved book, and as they accumulate enough strong tearsheets, they distill them down to a few important specific types of work. Then they successfully evolve their presentation into a box of laminations. How many? You probably won't want to show more than ten or twenty laminations.

Annual Reports or Brochures. These are usually a good addition to your samples—if they are good ones and if the pictures are excellent and well-reproduced. If they are badly done, it is better to leave them out. In any event, avoid overloading your presentation. If you show an annual report or brochure that carries some of your pictures and some by another photographer, I suggest you seal off the sections that are not

yours with a small attractive paper seal or plastic paper clips. If your picture runs on a page with somebody else's, don't mutilate the page by X-ing out the other picture. (See Chapter Thirteen on arranging, for advice on how to cut out and use problem tearsheets.)

THE EDITORIAL PORTFOLIO

Most (but not all) picture editors on magazines prefer to see a tray of 35mm slides in order to get an adequate sense of what subjects a photographer does best and what he or she likes to do. In addition to a general selection of work, they are interested in seeing a run of six, eight, or ten images from a picture story in order to tell how a photographer would handle a coverage. Editors also suggest showing a few personal pictures to give them an idea of the photographer's personality.

Along with the tray, I suggest you make up a book portfolio (with acetate sleeve protectors) to show off your best published work and/or prints, which may be in black-and-white or color. The book is generally considered better for your purposes than a box containing laminations because laminations limit you to fewer pieces than you may need. Pages can be leafed through more quickly and obviously—a photo essay might require half-a-dozen pages running consecutively—while laminations are more suited to single samples. You may not always show your tray and book together, but it is a good idea to have both on hand.

Portfolio Styles. You can buy some of the new, jazzy plastic or fabric portfolios (especially those from France) that are now available, but it is my feeling that most of these are rather gimmicky and more suited to the extremely young photographer. I don't recommend them for most editorial photographers I know. I prefer the good-looking leather, leatherette, or canvas books, custom-made if you can afford it, and built to hold inserts. (Ring binders are all right, but they can be visually distracting.) Books need not be black. Rich, deep colors work fine. And the new trunks described earlier, in the section on advertising portfolios, are also excellent for editorial use.

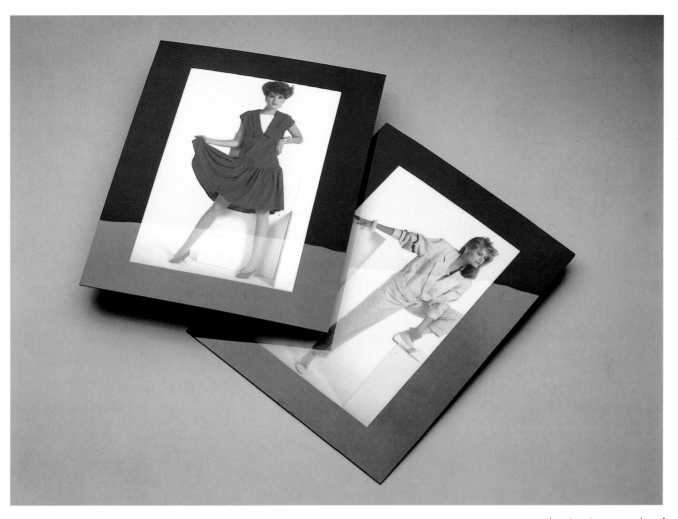

Laminations must be of high quality. Good ones, with borders handled in pleasing proportion to the sample, will enhance the appearance of your work as well as serving to protect it. Photo: Studio V

USING ACETATE PROTECTIVE SLEEVES IN BOOK PORTFOLIOS

I often hear what seems to me a rather subversive argument against using book portfolios with acetate-sleeved pages: "The sleeves get scratched all the time—and they're expensive to replace." Photographers who spend thousands of dollars a year on self-promotion, ads, mailers, long distance telephone calls, and client entertainment sometimes grumble at the few dollars involved in acetate sleeve replacements.

Figure it out for yourself. How much do a few dozen sleeves, amortized over a year, actually cost? And isn't this amount extremely small, compared with the income that a strong sales portfolio, carrying sparkling, spanking-fresh samples, can potentially bring you?

My advice: If a book portfolio suits your work, don't be penny-wise and pound-foolish.

Color slides can look more impressive when they are mounted in black mats instead of being shown in plain plastic sleeves. Black mount courtesy The Set Shop/Photo: Studio V

How Many Pages or Slides? As a rule, the number of pages varies somewhere between fifteen and twenty, which, counting both sides, allows you a total of thirty or forty samples or a few more, depending on your material.

The tray can use any number of slides. I've seen fine trays containing forty slides and excellent trays containing eighty or more images.

Portfolio Sizes. I lean to the 14 × 17-inch size, but 11 × 14 is also perfectly valid. The choice is up to you. One thing about the 14 × 17 format is that it holds a large, double spread tearsheet horizontally so your viewer doesn't need to turn the book sideways. On the other hand, the 11 × 14 size is easier to handle and takes up less space on an editor's desk. Incidentally, when using a paged book instead of separate laminations, you needn't worry about maintaining samples of the same size—the page acts as a uniform border for your tearsheets and prints.

THE GENERALIST PORTFOLIO

Unfortunately, for the generalist who works in all three areas of advertising, corporate, and editorial (as so many photographers throughout the country do), there is no specific rule for portfolio form. Some photographers develop a separate portfolio for each market. Others develop a general portfolio, consisting of a box of laminations, or an acetate-sleeved book, or a slide tray, which contains samples of each type of work grouped separately but arranged with effective transitional pictures between each group. The book then flows easily from one section to another. In this case, each section should exhibit the best characteristics of a portfolio designed for its particular market, and it may be helpful for the generalist to scan the suggestions for advertising, corporate, and editorial portfolios in this chapter.

GETTING THE BEST RESULTS WITH YOUR LAMINATIONS

A good lamination in prime condition can be a joy to behold, but a poor-quality lamination, or a dull, scratched one, can be a depressant to its viewer, lowering the impact of your portfolio. Some photographers are too offhand about ordering laminations. It will pay you to check out these tips.

Experiment with placement within borders. It isn't wise merely to specify the finished size you require and let your laminator decide where to place your tearsheet within the border. It's better to decide for yourself. For example, suppose you have an 11 × 14 vertical tearsheet to go on a 14 × 17 ground. Take a piece of 14 × 17 cardboard and try placing the sample dead center—see how dull it is. Move the sample up, down, or sideways until you arrive at a placement that makes the sample seem more dramatic, even though the distance from center may be minimal.

Get extra tearsheets. Knowledgeable photographers always arrange to get extra copies of good samples, either through the client or by buying them at the newsstand. These not only allow you to experiment with your laminations but provide backups for new laminations when the first set gets scratched.

Choose black borders. Black borders are generally considered best, although once in a while you'll have a tearsheet so dark that it calls for a white or gray border.

Choose a shiny surface. I recommend a shiny laminate surface rather than a dull finish.

Use a full-sized felt backing. Cover the entire back of the laminate with felt. When only the corners are covered, the material tends to rub off.

Crop when a spread won't fit. When you want to use a double-page spread horizontally but it's too wide, you can often crop just a little from each side without ruining the layout. Sometimes part of the type or some white space can be cropped. At worst, you can cut out the photograph, create a bleed edge, and laminate the sample. (For additional suggestions, look ahead to the section on problem tearsheets in Chapter Thirteen.)

Beware of false lamination. True laminations are made by sandwiching pictures between two sheets of plastic. The true lamination has a very flat, clear surface. The blistered, bumpy surfaces you sometimes see are produced by sealing only the edges of two pieces of plastic together, and they should not be used in a professional portfolio.

ON MOUNTED TRANSPARENCIES

Clients like to see color transparencies because they know that tearsheets don't always show how the photographer really shot the job. Black die-cut matte cardboard mounts provide the only effective form for showing color. Plastic sleeves make your slides look ordinary. (The only exception should be when a client seeks to buy a 35mm slide from your files.)

Maintain uniform sizes in mounts. The rule here is that you should choose a

mount for your largest transparency; then match this size in the borders of smaller transparencies. One size—8 × 10 or 11 × 14—is best. Try never to have more than two mount sizes in a presentation.

Use the new slide-tray boxes. The new heavy-cardboard tray boxes in colors such as deep blue, red, as well as black, are an improvement over the standard tray box and are very impressive.

Put your name on every mount. I strongly recommend that you place your name at the bottom of every mount, either on a label or by embossing, and preferably at the lower right-hand corner, where the viewer's eye naturally looks for a signature. There are three very good reasons for this:

1. It protects your samples in case your portfolio should be lost or misplaced.

2. It immediately tells your viewer which end is up. It can be very awkward to have to stop and turn a transparency around when the image is dark, complicated, or abstract, and the viewer isn't sure.

3. You achieve a *subliminal effect* by the repeated use of your name every time he or she picks up a transparency. The more times you can put your name before the client, the more the client will remember you.

If you use a label, it should be carefully designed in color and typography so that it does not conflict with the color in your transparencies. It should not carry your address, just your name.

Carousel tray boxes are now available in rich tones of black, blue, and red. A new accessory, not shown here but also available: the transparent plastic top, made by Leitz, which makes the trays look quite elegant, and also protects slides from dust. The Set Shop/ Photo: Studio V

FURTHER NOTES

Here are a few answers to questions you may have had but were afraid to ask.

What if you don't have tearsheets? It takes time to develop a collection of tearsheets strong enough to show. If that's your problem, there is only one thing you can do: Use excellent quality prints of great images and original color instead. I've seen some portfolios in which the prints were so strong that I never missed seeing tearsheets. If it's necessary, you can always explain your situation candidly. You are not pretending to be a well-known talent yet.

Will clients let you project slides? Some will, some won't. The larger the clients, the more apt they are to have a projector or a screening room available. Graphic designers in the corporate field and picture editors on major magazines usually prefer to project. But with smaller clients, finding an available projector presents a real problem; some clients won't want to be bothered. When you call to make an appointment, it is helpful to ask if a projector will be available. Some photographers carry projectors, or table viewers, along with them. I know one very fine rep in the corporate field who has a custom-made luggage case into which both her projector and a Lucite table viewer fit neatly. She is always ready for the occasions when those items are needed.

How do you project in a brightly lit room? When there is too much light in the room and you can't do anything about it, just place your projector very close to the wall. The images will show up small, but the smaller the distance of projection, the more saturated the colors will appear.

HOW TO RISE ABOVE YOUR COMPETITION

With competition growing stronger every year, you need to think about how to meet and overcome it. It can be maddening to be up for a job you know is just right for you, only to lose out to somebody else. It's even more disturbing to be unable to get a foot in the door while a competitor walks right in.

Never before has the field been so crowded and clients so besieged with photographers hungry for business. You need to think seriously about how you can prevail, not by lowering prices but by finding legitimate ways to position yourself so you stand out from your competition. You may be more sophisticated about marketing these days, and you may be showing greater concern about putting together a strong portfolio, but there is one method of self-advancement that you may not yet have zeroed in on: building your image. As a rep, I found the secret of getting a receptive audience with clients lay in building an aura of talent and success around each photographer. Once the reputation was estab-

lished, doors opened easily and a part of my selling was done automatically.

The ads you take out and the mailings you do are very important, but in my experience, these should be accompanied by as many other steps as you can manage to help you stand out from competition. You don't need to be a psychologist to know that it's human nature to respond to a "name" personality in any field. And your clients are no different than anyone else.

Your Work is a Product. You must regard your photography, however distinguished, as a product that needs to be sold. This calls for some hard thinking about anything that may be special about your product, and why the client should buy it instead of someone else's product.

Since we now recognize that photography is a *business* as well as an art, let's take a tip from the people who know how to make and market a brand-name product. Business people devote enormous energy to finding any angle that

A personal picture, shot because you loved what you saw, can reveal your unique vision and will help to make clients remember you. This beautifully composed and "felt" image was shot from an office window in Brussels, Belgium, by William Rivelli while he was waiting to take a photograph on a corporate assignment. It has evoked warm comments in his portfolio whenever he shows it.
© William Rivelli

will, in the buyer's eyes, differentiate their product from all the the others. They examine the qualities of their product until they find the special angle that makes it more "buyable" than other similar products.

FIND YOUR U.S.P.

In advertising circles, U.S.P. stand for "Unique Selling Propositions"—the angles that spotlight the special advantages or appeal of a product. Let me give you one of my favorite examples.

The advertising section of *The New York Times* caught my eye with this headline: "Parade to Promote Itself." (You know *Parade*, the national Sunday newspaper supplement.) The article described how *Parade* and its ad agency people planned a new ad campaign to

sell advertising space. "The key to the new battle plan," the article reported, "*is to stress* [Parade's] *difference from most other magazines*—the fact that it is published on Sunday." (Italics mine.) The first ad, headlined "*Parade* works while America rests," showed a young couple reading *Parade* over Sunday breakfast, and planning their purchases for the week.

In this campaign, the ad executives for *Parade* did what any good promoter does: They asked themselves, "What have we [*Parade*] got that's special? What can we say that is unique to our product?"

Define Your Message. Even if there really is nothing so earth-shakingly different about what you can offer, it's always possible to draw out something that makes a good point or two. As I've

Laszlo Stern used this stunning product shot in a photographer's promotion book. It brought him a great number of calls from major companies, one of his biggest assignments, and a good many new clients. © Laszlo Stern

Any fresh vision of a famous landmark is a promotional plus in a portfolio of any kind. © Jay Maisel

Robert Huntzinger demonstrates his ability to convey a subtle touch of humor in this image taken for an ad campaign. © Robert Huntzinger

said earlier in this book, every photographer—like every individual—has some points of singularity or uniqueness. What do you do that is worth talking about? How can you dramatize it?

Think of how Avis did it. Years ago Avis Rent A Car was struggling to compete with Hertz, the leading car rental agency. Avis had nothing better or different to offer. But its ad agency figured out a theme that caught on with the public: "We're Number Two . . . We Try Harder." That's the kind of thinking I'm suggesting.

Tic Tac found its U.S.P. too. Tic Tac (the tiny candy) had lost its competitive edge and was losing sales. The company decided to fight for a market comeback. Their marketing director was quoted as saying, "If we are going to fight, let's find a gun that works." That meant developing a strategy—giving consumers a reason for buying Tic Tac. Their ad agency came up with this idea: "Tic Tac, the one-and-a-half-calorie breath mint," to point up the fact that the "sugar-free" claims of their competitors didn't mean "calorie-free." Tic Tac developed a Unique Selling Proposition, and their marketing director credits the agency's single TV commercial for putting new life in the product.

These examples won't tell you how to prevail over your competition, but they should illustrate how, with some in-depth thinking, you may be able to come up with good ideas for emphasizing your special assets.

KEEP YOUR PORTFOLIO COMPETITIVE

The following few suggestions can work in any portfolio, regardless of whether it's intended for the advertising, corporate, or editorial markets.

Watch New Trends. Few things induce a client more toward leaning your way than seeing images in a portfolio that seem to say, "This photographer knows what's happening."

Father-and-child. It used to be that mother-and-baby was the symbolic parent-child image. That's still good, but

WELCOME TO THE LAND OF MILK AND HONEY.

The long rows of jars on a roadside stand shine like soft, sweet gold in the morning sunlight.

Green pastures climb slowly through the mist to join the rising mountains.

The air is so fresh, you'd think somebody had washed it. The sound of a lone bird mingles with the sound of a stream.

Away to the East, the mountains flatten into hills, then into farmlands stretching out endlessly toward the island beaches of the Atlantic.

And everywhere the fields are rich with crops, the waters are rich with fish, and the air is rich with the smell of flowers.

And the land is rich in history. It is the land of colonists, of pioneers, of the Cherokee Nation.

North Carolina. It is a land of promises kept.

A land of plenty. A land civilization has touched, but never destroyed.

It is an abundant land, filled with good things.

And it is a land that reaches out and invites you to come and share. NORTH CAROLINA

For more information, and the free North Carolina Travel Package, write North Carolina Travel Department 001, Raleigh, NC 27699

there are now more pictures of young fathers involved with their children. For example, the father may be holding a newborn baby, while the mother relaxes at his side; or the father may be holding the hand of a contented tot while they walk down a lane; or a father might be helping a child learn to swim. These can be candid editorial situations or advertising illustrations using models.

The new senior citizens. Demographic studies show that the increasing number of people over the age of 65 will become an influential force in the decades to come. More and more, this age group includes vibrant, handsome, active individuals who have little similarity to the "little old lady" or "little old man" stereotypes. It won't hurt to include an example of this new breed in your portfolio.

The physical fitness craze. Health buffs are buying and using enormous quantities of body-building equipment, athletic clothing, special foods, and vitamins. There are plenty of ideas for portfolio pictures here.

Computers and child prodigies. People are now trying to teach babies how to use computers. Children and computers are contemporary.

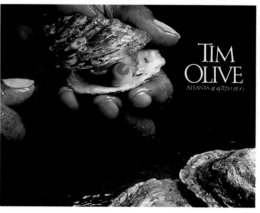

TIM OLIVE
ATLANTA 404 872 0100

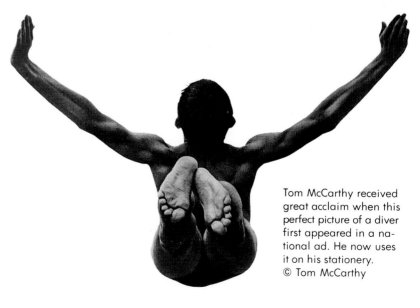

Romantic couples such as this one by Burk Uzzle continue to be a popular and salable subject in portfolios of all kinds. © Burk Uzzle/ Woodfin Camp Associates

You'll see a lot more pictures of marvelous looking older couples like this one, top, from an ad for St. George's Club, Bermuda. It won't hurt to reflect your awareness of this trend, if the subject interests you. © Patricia Barrow/ Words & Co.

Special effects that include people. Whereas the first surge of special-effects photography involved purely electronic marvels, some of the latest images now include people.

Workers as real people. In corporate work, there are still plenty of good photographs being shot of workers doing their jobs at machines, but something new has been added. We are now seeing more interpretative studies of workers standing next to machines, smiling, talking, or just looking into the camera.

No clichés. Be wary of picture treatments that are seen in everybody's portfolio. For example, while you can still get away with a picture of an oil storage tank with a staircase spiraling up its side, why not try for something different? Other clichés to avoid: the standard shot of a man or woman walking past a stucco wall (now its being done in other versions, using a wide-angle lens and a different perspective); the "big sun" pictures, which are now seen in bigger versions; and blurred motion shots, which are fairly old hat, unless they are shot with such technical authority and artistry that they are worth looking at.

An example of the new trend in showing lively, active senior citizens, this picture, far left, by Guy Gillette shows an older couple with a flight chart.
© Guy Gillette

Henry Wolf conceived this image for a page in Channel Thirteen's monthly magazine to convey the idea that listening to Verdi's Requiem is comparable to being in a cathedral.
© Henry Wolf

Conceptual Illustrations. Not every photographer has an interest in, or the talent for, taking an idea and translating it into visual terms. But if conceptual photography is up your alley, be sure to emphasize it. This talent is worth money in advertising illustration and is a highly desirable commodity for book and magazine cover work. It is particularly valued in corporate photography, where huge conglomerates are spending large sums on institutional advertising campaigns aimed at building corporate identities along with good will.

Famous Names and Places. Everyone likes to see a great shot of a celebrity. Whether they admit it or not, most clients are impressed by a photographer who is important enough to photograph famous people. And a terrific picture showing a fresh look at a memorable building or landmark (but again, not a cliché photograph) gives them a feeling of recognition. Clients tend to remember these images.

TACTICS FOR BUILDING YOUR IMAGE

It can really hurt when you are up for a plum assignment and it goes to another photographer whose work is of lesser

Hair styles change and awareness of the changes is important. Here, an example of the punk look.
© Frank Schramm

quality, or at best about the same quality, as yours—but who has the advantage of a name that impresses the client. Establishing a reputation for a certain kind of photography, or becoming known as the best in your class, is worth so much in its effect on clients that it can be a great mistake to neglect this larger aspect of your career.

A number of elements go into image building. The secret is to orchestrate the parts so they all work together at the same time. That's the way to build a reputation fast. (We all remember how we become conscious of a new celebrity: The first time we hear the name our reaction is, "Who's that?" The second time we say, "Sounds vaguely familiar." The third time, we have a flash of full recognition.)

Here are a few of the elements of image building:

Perfect casting, perfect expressions, perfect nuance of humor; perfect everything is evident in this picture. © Ken Ambrose

- Seek out clients who use the type of work around which you want to build your reputation. The work you will get from these clients will produce the right kind of samples, with which you can get similar work. For example, as a rep, I always worked with creative photographers and hence I contacted creative clients. This was a part of our formula for success. I located many of our best clients by keeping myself informed on who was using the kind of pictures we had to show.

- Try for credit lines whenever you can, even if you must concede something else in a deal in order to get them.

- Make sure that your best work is sent to all legitimate sources of publicity, including art directors' competitions and the various graphics annuals published in the United States and abroad. Remember, the more frequently people see your name, the more luster it acquires. Don't just assume clients will submit your work; you can check with clients if you want to, but it doesn't hurt to send your work out independently at the same time.

- Put some effort into getting your name into photo publications and the photo trade magazines, with pictures, or articles about you, or with news of something special you are doing. This includes local, regional, and national publications, as well as the handsomely printed magazines such as *International Photography* put out by Eastman Kodak Co., and *Closeup* by Polaroid, if you use Polaroid film. All publicity helps your buildup, even news in the local bulletins of photographic organizations to which you belong. Also, if your work is on a suitable level, try to get your best work into the prestigious European photo magazines.

How All This Relates to Your Portfolio. Some of these ideas should help you produce a more powerful sales portfolio. In the larger sense, building your name—your image—creates the climate for respectful attention to, and acceptance of, your portfolio when you show it.

Hennessy
The civilized way to say good night

The world's most civilized spirit

How do you make an idea come through visually? Robert Huntzinger handled the entire advertising campaign for Hennessy Cognac France in inspired fashion. © Robert Huntzinger

DIGGING IN America seems determined at last to develop its enormous coal reserves. Essex mining cable will help get that urgent work done. Essex is a United Technologies company. So are Pratt & Whitney Aircraft, Carrier, Otis, Sikorsky, and quite a few others. Together, they form a corporation that's the tenth largest manufacturing company in the United States, and growing. Remember United Technologies Corporation, Hartford, Connecticut 06101.

COLOR GUARD

The three pictures above and at right by Jay Maisel are from a now-famous campaign by United Technologies Corporation. The sheer graphic power of the pictures and their use on two page spreads in magazines attracted much attention.
© Jay Maisel

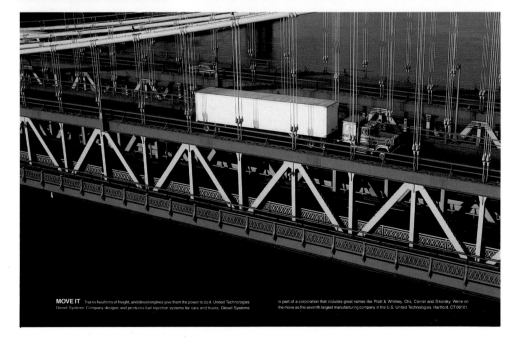

MOVE IT Trucks haul tons of freight, and diesel engines give them the power to do it. United Technologies Diesel Systems Company designs and produces fuel injection systems for cars and trucks. Diesel Systems is part of a corporation that includes great names like Pratt & Whitney, Otis, Carrier and Sikorsky. We're on the move as the seventh largest manufacturing company in the U.S. United Technologies. Hartford, CT 06101.

A SYSTEM THAT TAKES THE GUESSWORK OUT OF EDITING

Edit. v/t. *to select, emend, revise and compile . . . to make suitable for publication or for public presentation . . . to assemble . . . by cutting, rearranging, and combining . . . component parts.*
—Webster's 3rd International Dictionary

In the chapters to follow you will find the details of a system that can make the editing of your portfolio easier, infinitely more accurate, and more authoritative. I developed this system over a period of years and I've refined it as I've gone along, editing hundreds of portfolios. It's a surefire method for culling down your samples to the best pictures and putting them into an effective order.

I've divided the system into four distinct parts. First, you sort your pictures into groups according to subject or style. This method goes far deeper than the casual grouping you may have been doing and lets you turn the confusing, unorganized mass of images that you have to begin with into a clarified set of related images that is easy to work with. It sets the stage for the second part: selecting your best pictures.

Third, you analyze your choices to determine which will be most important from a selling standpoint, and decide which should be your priorities. Then fourth, you arrange the pictures into a unified and convincing flow.

EDITING IS A SKILL YOU HAVE TO LEARN

We all groan and complain about the headaches we get from editing, but few of us recognize that editing is a special skill which must be studied, thought about and learned, just as we learn how to shoot pictures and how to print them. The idea that if you're a good photographer you can edit your pictures is out of date. The ability to edit is not a natural gift like having a "good eye" for pictures. For one thing, we are all too close to our own work to maintain the necessary objectivity; for another, there are too many technical skills involved.

In the film industry, so closely related to photography, everyone knows that editing is a learned skill and a highly specialized, highly paid craft. Film editors get credits just like directors and producers. They win Hollywood Oscars, and it is an accepted fact that film editors can make or break a movie by the way they use their skills to "cut, jump and rearrange the frames," as it's been described. You can make or break your portfolio in the same way. A good editing job is far too important to your career—not only to producing a powerful sales vehicle in your portfolio but to handling any other representation of your work, such as exhibitions, books, articles, even your self-promotional material—to not treat it seriously and attempt to learn some of the skills you need.

A Basic System. I've called the steps for editing outlined in this section a system. The first part, which follows, is indeed a basic new system in the way I've developed it and worked it out. The other parts, of course, cover too many variables and intangibles to be exactly systematized. What these contain is a combination of practical suggestions, fundamental principles, and rules to be followed, plus working techniques and "tricks of the trade."

Take it easy. Don't rush through the early parts of the work to get to the arranging section. Each part calls for a different kind of thinking and will help you build a good foundation for the last part.

SUGGESTED EQUIPMENT FOR EDITING

You don't need elaborate equipment for editing, but you do need a *few* minimal items. (It's been said that a photographer can edit merely with the aid of a good magnifying glass, but you can also take a picture through a pinhole in a box. Why should you shortchange yourself when editing?) It's hard enough to make fine distinctions between pictures even with the best of equipment. I suggest you give yourself the advantage of working with the best mechanical aids you can afford to buy.

For Editing 35mm Color Slides. *A good projector.* To my mind a good projector is worth its weight in gold. Many photographers, it is true, use only a jeweler's loupe. This is excellent for detecting sharpness and detail, but you don't get the overall impact of a picture as much as you do when you see it enlarged and at a slight distance. For one thing, you may see the fine details with a loupe but you need to get the feel of how these details work with each other in the total picture in order to judge its quality. Furthermore, when it comes to working out the arrangement of images in a tray, I think there's nothing like seeing slides projected one after the other on a screen to give you a sense of how the presentation flows.

Photographers sometimes take incredible leaps in color quality when they start editing with a projector. I once knew a young photographer who complained to me that although he had done many stories in black-and-white for the *New York Times Magazine*, he could not get a color assignment. I suggested we project his 35mm color slides, and when we did this, he was startled: "I can see that I've been thinking black-and-white while shooting color," he said. "Now I know what I need to do." Within two months he was doing color assignments for the magazine.

A remote-control attachment. Don't skimp on this. It costs only a little extra, and lets you save your energy for concentrating on the images. You won't have to reach over to press a button every time you want to advance a slide.

A stack loader. One of your best investments, and inexpensive at that. I'm always surprised to see a photographer take the time to slot unedited slides into a tray, when it's so much faster to feed a whole batch of slides into a stack loader at one time.

A jeweler's loupe. Several models of loupes are made for lithographers and photographers. Some have battery-powered light bulbs for viewing contact sheets. It's worth trying to find one that is made to let you see the entire frame. Jay Maisel uses an interesting device—a Nikon DW 2 magnifying viewfinder made for Nikon cameras. It's a pleasure to use.

A light box. The bigger the box the better. Then, when you have many pictures to edit you can work with them all at the same time. This is especially important for organizing slides into a fluent arrangement. Check the color temperature of the light source in any box you are considering. The industry standard is 5000K (degrees Kelvin), and anything much different than that will distort the color of the slides as you view them. Also, look for a box that has even light distribution from edge to edge. Some boxes have hot spots that make it difficult to judge the accuracy of your exposures.

For Black and White. When editing contact sheets and prints, all you really need is a loupe with a clear skirt to allow light to fall on the contact sheet (or a magnifier with its own battery-powered bulb), a pair of cropping Ls, and a red grease pencil.

There are numerous other gadgets you can obtain to help you edit, but as they are not essential, I leave those choices to you.

Grouping by subject effectively

Here pictures are grouped by subject or style to show how, by putting related pictures together, you can emphasize the points about your work that you want your client to be aware of. Pictures 1 and 2 show two agricultural subjects; pictures 3 and 4 show two different versions of shots of workers; pictures 5 and 6 are powerful and graphic; and pictures 7 and 8 are both industrial long shots marked by dramatic composition and linked by expertly handled, twinkling lights. Picture 9 illustrates a plane. This picture could be used to start a series of plane shots, or it could lead off a series of transportation shots.
© Dick Durrance/ Woodfin Camp Associates

Haphazard grouping

The same excellent pictures you see above are shown here in a random grouping that fails to deliver a clear message about the photographer's strongest subjects.
© Dick Durrance/ Woodfin Camp Associates

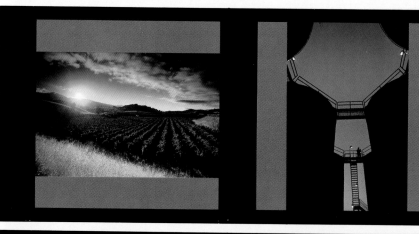

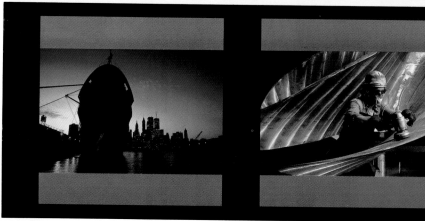

THE RIGHT WORKING SPACE

Avoid cramped space when you start editing. Many photographers who take meticulous care of their equipment and maintain a shipshape darkroom make the mistake of trying to edit their work amidst confusion. Clutter distracts the eye and hampers concentration.

It will pay to spend time designing your work space efficiently so that everything you need is handy. Light box and projector should be next to each other. Smaller items—magnifiers, masking tape, cropping *L*s, transparency mounts, rubber stamps, and pads—are best kept in a drawer or box within easy reach.

If you don't have a large counter or desk on which to spread out prints and tearsheets, a clean floor will do, with wrapping paper unrolled where advisable. (Watch out for strolling pets and children.)

Pete Turner's studio. When I first worked with Pete Turner, who is known for his efficient editing habits, this is how he had his work space set up for maximum efficiency:

• An *L*-shaped arrangement of desk, counter, and light box, with the projector was on the counter next to the box
• Swivel chair
• Color file drawers beneath the desk and counter
• Desk drawer containing working materials
• Large viewing screen on the opposite wall that could be rolled up and down automatically by pressing a button on the desk
• A long wall-counter for laying out prints

Put your rejects in neat piles. I learned a long time ago that when I want to edit fast and efficiently I can't afford to be distracted with miscellaneous material projecting into my field of vision. As you reject a picture, don't just toss it aside near the work you are editing. Make a place for a pile of rejects some distance away from the images you are working with. A little thing, perhaps, but psychologically important. Besides, it's too easy to mix up your choices and rejects if you aren't careful. Also, don't toss reject slides haphazardly into haystack-like piles. You may later want to retrieve an image you find you need and have to lose time setting all the slides straight.

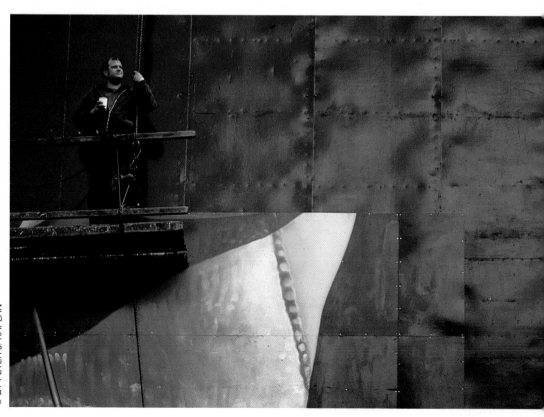

FIRST: SORT YOUR PICTURES ACCORDING TO SUBJECT

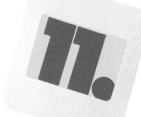

I can't overemphasize the importance of this task. For me, it accomplishes something only a little short of magic. You may start with a miscellaneous, unorganized conglomeration of images, but by methodically breaking the mass down into smaller and still smaller groups of related pictures, you will arrive at a point where you can begin to choose effectively—and organize—the pictures you want to use in your portfolio.

This process seems to be especially valuable for sorting out a large collection of pictures, although the same principle also applies to a small number of images.

This preliminary sorting will be helpful in editing a portfolio for any one of the major fields: advertising, corporate, or editorial, or a combination of fields. The steps may, at the beginning, seem to require a lot of unnecessary effort, and certainly they go further than the usual preliminary work you may have been doing to start editing. But take my word for it, if you are like most of the photographers I know, the process will become a habit and will save you much time in the end.

TO START

Bring together everything you are going to look through. Try to keep extraneous material—such as carrying cases, envelopes, and rejected samples—elsewhere, out of your line of vision; they could be distracting in a subtle way.

If your material includes prints, tearsheets, and transparencies, keep each type of sample separate, and start with whichever you consider most important. Obviously you'll first get rid of your clear misses and most inferior images.

Transparencies go on the light box. Prints and tearsheets go on the counter and sometimes, since they take up a lot of space, on the floor.

For clarity, I'll demonstrate how to use this process of sorting with a large collection, say, several hundred, of 35mm color slides including a variety of subjects. (It won't matter here if the slides are intended for an advertising, corporate, editorial, or general portfolio; in any case you'll follow the same steps.)

Step One. Group your pictures according to their *general subjects*. Starting with the first slide you pick up, decide what general category it belongs to, and place it on your light box. Do the same with the next image. Continue classifying and segregating your images, building up piles of each subject. Don't worry if the piles grow quite large in this step; they'll quickly grow smaller.

Let's say you find yourself with a number of piles of images under various headings, the major ones being Automobiles, People, Nature, and Still Life. Your first pass through the pictures has now given you some general groupings, as illustrated on pages 96–97.

Step Two. Now differentiate further. Go through each pile of pictures again and break them down into smaller groups according to more *specific subject classifications*. This isn't too difficult. Obviously, Automobiles covers various vehicles and People covers a lot of territory, too. Remember, what you're doing is creating smaller groups that will be easier to handle in several important ways when you do the rest of the work on your portfolio. Refer to the sample subdivisions in the illustration which follows.

Step Three. Now break down the pictures in each pile according to circumstance or, the usual term, *situation*. A rough definition is the activity, location, or environment involved in a shot, but anything that makes one picture different from another of the same subject might suffice. Further distinctions include dress, mood, facial expression, whether the person is alone or in company, and technical elements such as composition, photographic angle, light-

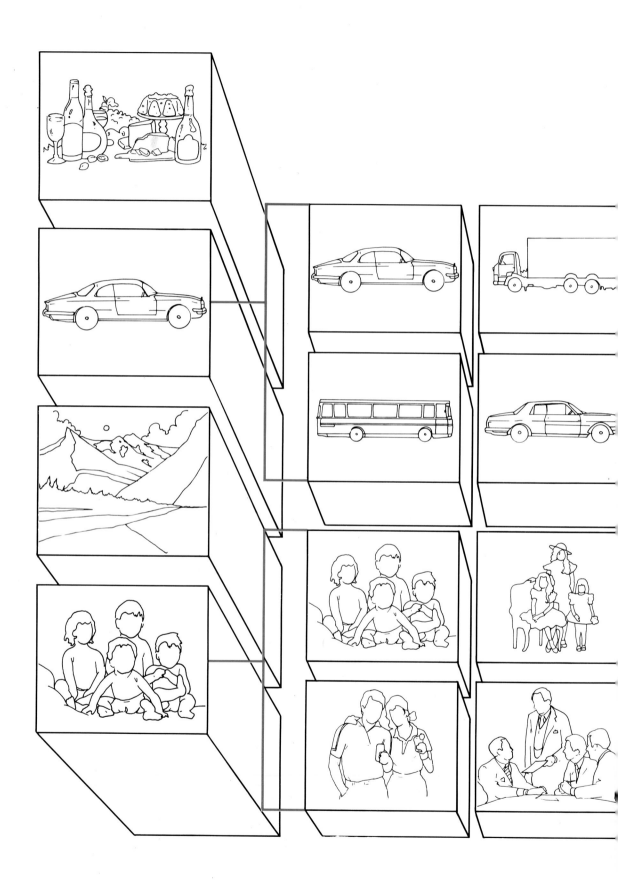

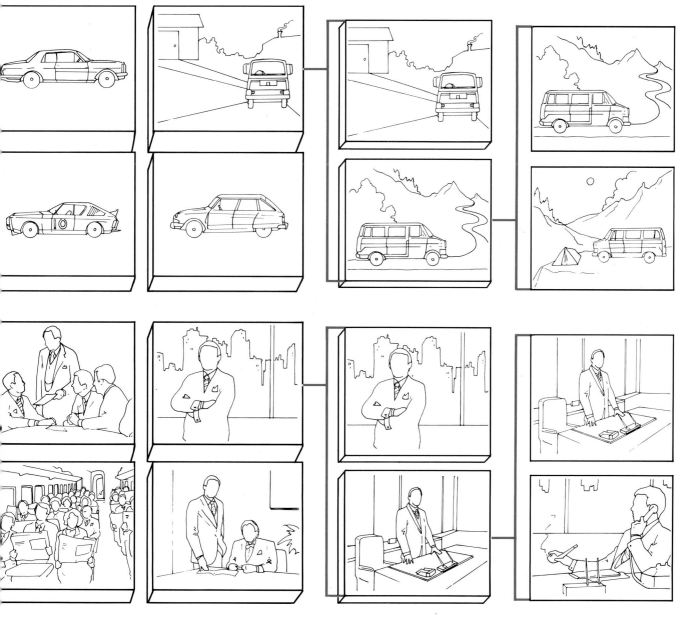

ILLUSTRATIONS BY
PERRY A. REALO

ing, or special effects.

Let's follow through with the subdivision called Business Executives. Suppose all the pictures in the pile are of one man, Mr. X. He may have been photographed in many different situations—reading the paper at breakfast, working in his office, talking on the telephone, in conference, heading home on a commuter train, having dinner with his wife. What you want to do now is to place every situation in its own pile.

Similarly, we have already reduced the general group Automobiles to several smaller groups, among which is Passenger Cars. But passenger cars travel to many places and are photographed in a great number of situations. So in this step you need to separate those different situations.

Step Four. (Just one more—truly!) This time, following the same principle as in Step 3, divide your situations into *specific variations* of each. You'll find the size of each pile dwindling, and you'll probably be eliminating obviously inferior versions as you go along.

CHOOSING FROM AMONG NEARLY IDENTICAL IMAGES

Everyone knows how frustrating it can be to have to choose one version of a shot from a run of shots between which there are only the most miniscule differences. My method of sorting pictures into related subgroups will again prove helpful.

The recipe. Take the whole group of similar shots and separate them into small piles of each variation. Segregate them by small deviations such as pose, perspective, composition, lighting, camera angle, foreground, background, and, if people are involved, expression and movement.

For example, using our business executive again, when editing a series with slight variations in pose, you can become extremely fussy. Put the images showing Mr. X with his elbow up, in one group; those with his elbow down a little way, in another group; and those with his elbow on the desk in yet a third group. Segregate broad, medium, and slight smiles, and so on.

Certainly it is a chore to analyze pictures in such minute detail, but you will be amazed at how quickly it will help you to compare and decide among them. If I have a good many variations I am able to narrow them down rapidly, first to just the best two or three versions, and then (a little more slowly) to the best one. There are so many fine nuances and combinations of elements that you can't possibly depend on your visual memory to make accurate comparisons. So, sort and organize your samples so that you can compare like images side by side.

ADDITIONAL SUGGESTIONS

Group by style as well as subject. If you have a particular style, by all means group the pictures that demonstrate that style—whether it is strongly designed images, high- or low-key lighting, or an unusual mood. A portfolio can consist of many subjects handled in your own style, or it can include just a single subject handled in your individual style.

Group by special technique or treatment. Special-effects and multiple-motion images, or reproductions that combine two or more images (only if they are really fine) may be grouped together.

Group by category as well as subject. In this process, I define *subject* as a group of related things and *category* as a broader group, covering several similar subjects. To illustrate, if you group together the subjects Automobiles, Trucks, Airplanes, Trains, and Ships, you will have the category Transportation. Or if you add the subjects Swimming, Boating, Biking, and Hiking to the subject Tennis, you will have an attractive category of Leisure Activities or Sports. Again Liquor Bottles is a subject, while Still Life—including other objects—is a category.

Leave room for a miscellaneous group. You will always have a few fine pictures that don't fit into any category but do demonstrate your personal way of seeing. It is a perfectly good practice to show these in a small miscellaneous group, which can include anything from a single great design shot to a magnificent display of fireworks or a unique photograph of a

flower. Clients enjoy seeing these, and they add to your stature.

Eliminate pictures as you go along, but don't stop to debate their quality or usefulness—just toss out anything that seems unimportant. You'll have time to deliberate later.

WHAT YOU WILL HAVE ACCOMPLISHED

You may only really become aware of how much these steps are worth when you come to the next parts of your editing. You will find that:

1. Repetitious shots will become quickly obvious; the need to leave out some pictures when there are too many in a group will become clear.
2. Comparisons for quality will be infinitely more accurate; it will be easier to choose the best pictures.
3. You will get a bird's-eye view of what you actually have in your material and what you may be missing.
4. You will begin to get some idea of how you may want to arrange the portfolio.
5. You will have a handle on all the pictures—a way to probe into what was before only a confusing conglomeration.

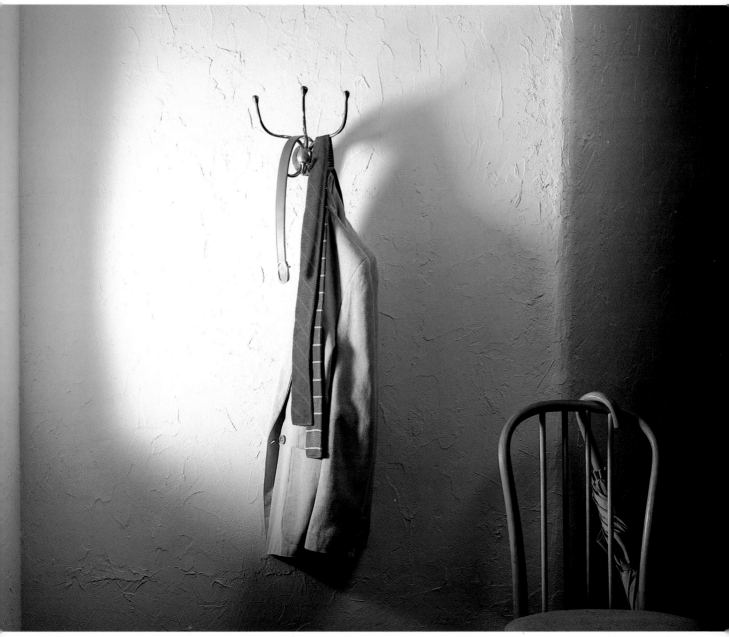

SECOND: CHOOSE YOUR BEST PICTURES

In this part of the process, keep your mind solely on judging your pictures for their quality as images and nothing else. Don't try to think about which ones will have stronger sales appeal, or whether you have too many or too few on this or that subject. Those considerations come later. You can, of course, eliminate inferior pictures as you go along, but this is not your major aim at this point.

What Does "Best" Mean? There are no absolute rules for judging pictures. You need only to read critics' reviews of photographic exhibitions and picture books to realize how widely they differ in their aesthetic criteria. Not only are there differing schools of thought, but individual reactions to pictures are often influenced by personal predilections.

That doesn't mean, however, that there are no aesthetic qualities inherent in all good photographs, which must be understood and observed. In this book, however, it is not my purpose to speak as a critic. My purpose here is to try to help you select the best pictures for your portfolio by telling you some of the criteria and methods, I recommend for selecting images.

WAYS TO DEVELOP A GOOD CRITICAL EYE

Look at Good Pictures. The more you look at fine pictures, the higher your level of personal taste will rise. It is important to see exhibitions in museums and galleries, look at picture books produced by distinguished photographers, and keep abreast of the new pictures being published in the various prestigious photographic magazines both in the United States and abroad.

Don't Concentrate on Technique. When you look at a good photograph, don't make the mistake of paying attention only to its technical aspects. Instead, think of the idea behind it and how well it is conveyed. Ask yourself what visual elements make it powerful. Sometimes it's a good idea to compare the way the concept is handled with the manner in which you would treat the same theme.

Study Works of Art. Try to develop your understanding of the aesthetics of all art—painting, sculpture, music, literature. (Be sure to include experimental and avant-garde art, as well as the traditional forms.) In all the arts, we find similar principles of structure, unity, and integration of form and content. Remember that good photography must follow the same aesthetic rules.

TIPS FOR JUDGING PICTURES

The following list is a catchall of tips, tests and helpful hints for judging the quality of your images.

Examine Every Detail. I advocate one inviolable rule: Go over your images with a fine tooth comb. Systematically check every detail point by point, detail for detail. *Remember, nuances make a picture.* Cartier-Bresson once said, "The difference between a good picture and a mediocre one is a question of millimeters."

Without a detailed scrutiny you may not notice a small detail that can mar an otherwise good picture—but your client will, and may silently hold it against you.

How to Do Point-by-Point Checking. First, take a good look at the total image to get the feel of it and evaluate its visual impact. Then go over it meticulously: Pick a starting point—whether at center, left or right doesn't matter—and scan the entire surface. I usually start at the upper left and direct my eye around the photograph in narrowing concentric circles or ovals, but there is no rule. Sometimes I start at the central point of interest. Your eye will more or less dictate your starting point. The following are some of the points to check.

Jay Maisel, noted for his insistence on rejecting all but *the best* shots in any take has over a million pictures on file. Here he is in his studio, awash in a sea of slides. © Chris Callis

Check the edges. It's easy to overlook a disembodied hand floating in a corner, a tree branch that doesn't belong, or a window frame that sneaks into the scene. If you catch something distracting on the edges of a print, you often can crop it out. In a transparency, you can have a duplicate made that will eliminate it.

Check facial expressions. Look carefully at a smile. Is it a real smile or just a grimace? Is there a slight frown on a supposedly cheerful face? Compare similar images to see which is best.

Check subtle shadows. A slight shadow can add strength to a picture. Sometimes it doesn't belong, and hurts an image. If you are deciding between several versions of an image, compare details such as shadows and out-of-focus highlights.

Does the picture "read"? Pictures must be readily intelligible to the viewer. Clients go through portfolios quickly, and they become annoyed if they have to waste time guessing what they are looking at. If the picture is too dark, confusing, or fuzzy, or if the point of the picture is so unclear that it needs explanation, leave it out of your portfolio.

Block out questionable details. It often helps to hold your hand over a detail—a shadow, a highlight, a foreground, or perhaps a background area—as a painter does. Study the picture, and then take your hand away. See if the detail in question seems to help or hurt the overall image.

Be Absolutely Ruthless. Another four-star rule: There is no other word but "ruthless" to describe the sternness you must exhibit in choosing your best pictures.

Aim to show only terrific images. If you must, show fewer pictures—but great ones. If you are in the early stages of your career and don't have many good samples, a few fine pictures will do you more good than a lot of ordinary ones. You can be sure that top photographers in the business don't hesitate to discard pictures that don't quite come up to par. Have you heard of the four- by eight-foot box Jay Maisel keeps in his studio, filled with reject 35mm slides? It is quite a sight! (He formerly had a four-foot-high wire trash basket but that wasn't large enough.)

Once in a great while you might have to include a less-than-fine image just to prove that you have done something in a particular area. In that case, as soon as you can, replace it with a better shot.

Forget the excuses. Clients have no way of judging how good you are except by what you show them. Trying to explain why you couldn't get a better shot will only leave clients with the impression that you can't be trusted on a job. Also, don't show a poor tearsheet with the excuse that the art director "picked the worst shot."

When you can't decide, sleep on it. Hold the "iffy" pictures and sleep on the decision. You can usually make up your mind later.

Beauty shots must be checked meticulously in every detail, according to Nicholas de Sciose. He watches what is happening with a model's eyes, ears, and cheekbones for lines that may detract; he watches elbows, armpits, breasts, shoulders, and neck. He has used this picture successfully in self-promotion ads.
© Nicholas de Sciose

A SIMPLE TRICK TO HELP YOU JUDGE A PICTURE

I have developed a good way of deciding whether a picture is really strong or just a flash-in-the-pan. I look at the image and either close my eyes or look away, and I visualize it printed as a full page or a double spread in a magazine such as *Life*. I pretend that I just came across the picture and don't know who shot it. This stratagem gives me a sense of distance from the work and allows me to see it more objectively and in a fresh way. Sometimes I decide the picture looked good at first glance but isn't dynamic enough to deserve the space. Other times I am more certain than ever that the image is a powerful one and should be used in the portfolio. If you find this method of visualization hard to do at first, keep trying. You will find it one of your most valuable editing tools.

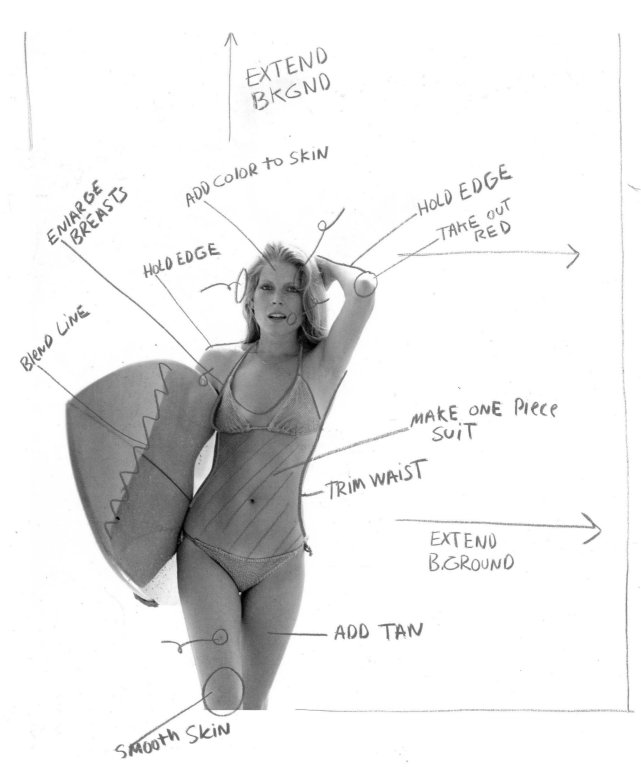

How to check your picture point-by-point. Here are art director Nick Giroffi's notes on points to be retouched in a swimsuit ad. Photograph with retouching indications courtesy of Spano/Roccanova Retouching Inc.; photo by Peter Sahula

Avoid Subjectivity in Choosing Pictures. Certain mistakes in choosing pictures are commonly made by most photographers, even by some of the best. Most times, the errors are made without the photographer being consciously aware of why the mistake was allowed to occur.

One of the most common mistakes we are all likely to make is to select a picture because of hidden emotional reasons that have very little to do with the actual quality of the image. We must be able to look at such pictures objectively, recognize what it is that triggers such attachment, and finally say, "I love it, but good-bye." Here are some of the most notorious sins of subjectivity.

Fond memories that influence your judgment. If there's one danger to guard against, this is it. Maybe you were in love the day you shot a picture. Or the scene was so peaceful, you can still smell the scent of the freshly mown hay and hear the birds singing. So you love the picture. But look again. Is it really an "image"? Remember, your viewer isn't privy to your memories, and he or she will judge it with a cold, calculating eye. Be on guard for the moods, sounds, smells, and colors you might recall from the time you shot a picture. You love the picture for the memory it invokes, but is it really a fine picture?

Pictures of your children. Admittedly, all children are beautiful to their parents, but they may not be photogenic or their pictures may not be suitable in other ways for your portfolio. Don't let your love for them draw a curtain over your eyes when evaluating their images. Ditto for pictures of husbands, wives, lovers, and all relatives.

The picture that was so hard to get. But is it good? Don't make the mistake of placing a high value on a picture simply because you overcame great difficulties in shooting it. A picture is not necessarily wonderful because it was a challenge to make. Even if you had to hang by your feet from a chandelier to get the shot, that act of daring doesn't mean the image is good enough for your portfolio. What

you want from your portfolio is sales, not an "E" for effort.

Visual puns that don't work. I'll give you a typical example. A picture may contain a street sign that reads "Saints' Street," while walking the street are some extremely rough-looking characters. A clever pun? No. The street sign is so tiny the viewer fails to notice it and wonders what point the picture is making. It's all in the photographer's head. If you want to play jokes or make serious symbolic comments, think twice: Make sure you are not the only person who "gets" it.

You know "That's how it was." But does the picture *show* it? Your subject was angry, or afraid—but did you actually catch the tense facial muscles or the fear in the eyes? Does it come across? There is an old story about the film director shooting a scene in front of the Pyramids. He rejected the first take and reshot it with papier-mâché pyramids, because "the real ones didn't look 'brooding'

In this picture, one of the most famous of all W. Eugene Smith's photographs, you'll see a slight shadow behind the feet of the two children. This is a very tiny detail, but it helps integrate the children into the scene.
© W. Eugene Smith; photo courtesy Center for Creative Photography

A touch of fantasy is
extremely well done in
both of these pictures.
Nancy Brown's horse
and couple has a mem-
orable quality; Nicholas
de Sciose's beauty-fash-
ion shot is both dis-
tinctive and amusing.
© Nancy Brown,
© Nicholas de Sciose

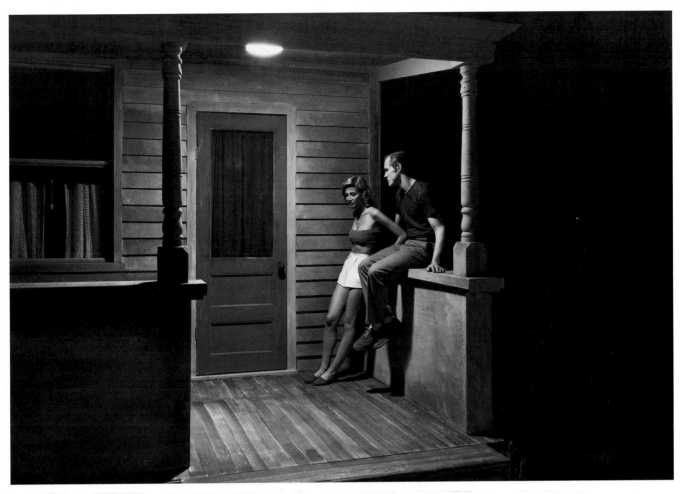

enough." The director might have gone a bit too far, but the thought is still valid. Check closely to make sure the reality of a situation registers in your picture. You can't just assume that what you know about the photograph will reveal itself automatically.

WATCH BODY LANGUAGE IN PEOPLE PICTURES

We can tell in real life something of what people are thinking and feeling by watching telltale signs in posture and gesture. It's important to notice the same clues when choosing pictures.

Models pretending to be relaxed. I often see ads for down comforters or electric blankets in which the models are stretched out in bed, supposedly blissfully asleep. But their faces are tight and unrelaxed; they are obviously faking sleep. This visual cheating makes me feel as though the advertiser is lying to me. In posed "sleep," the face does not really change, only the eyes are closed. In real sleep, the facial muscles relax and the lips soften. This is the kind of *visual discrimination* that makes the difference between an average photographer and a great one.

Smiling lips, expressionless eyes. I call these "portrait fakeouts." In the past we often saw more of these than we do now, particularly in magazine cover shots of pretty girls. Phillipe Halsman, renowned for his portraits, used to say, "If you don't have a compatible relationship between the lips and the eyes, you have missed the picture."

Your friendly business executive. Especially in corporate work, you are expected to shoot your subjects looking relaxed, genial, masterful. Be sure to look not only at the face but also at your subject's hands, feet, and body. If the hands are tightly clenched, the legs and feet are pointed stiffly, the cords in the neck stand out, the shoulders are hunched, or the head tilts at an odd angle, then the

For me, this haunting photograph of a couple on the porch reaches the level of high art. It is one you won't easily forget. © Ken Ambrose

Watch what "body language" reveals in your photographs! In Suzanne Szasz's picture of mother and children, notice how the little girl's left hand shows itself in a caressing gesture, while her right hand seems to be pushing mother and new baby away—an expression of sibling ambivalence.
© Suzanne Szasz

The two hand pictures below are from photographs of business executives; they reveal a discomforting tenseness. It is best to watch what hands reveal in your images and to choose the one that shows hands, feet, and body posture (as well as facial muscles) relaxed.
© Greg Edwards

A POINT OF PROCEDURE

Plan on going over your pictures three times.

The first round. Don't stop to analyze each image. Just take everything that appeals to your gut reaction.

The second round. Go more slowly and thoughtfully through the work. Leave out pictures that clearly seem to be unnecessary, repetitive, or inferior.

The third round. Now is the time to make decisions. Take your time and analyze each image. Compare similar pictures. Even now, if you are torn between two pictures, don't spend time agonizing, but hold both your choices. Remember, you are not narrowing down to a final selection for your portfolio yet. That will come when you begin organizing your samples, and the final choices will depend on other elements besides the quality of the images. Be sure to maintain the subject groupings of your work. You will need those groups later to do additional editing.

An exceptional version of the female nude, above, left.
© Jay Maisel

Such a simple image, a gauzy curtain at the window, shown top, right, could easily be passed by in editing. Yet the mood it evokes is so powerful that it can be used in a portfolio successfully.
© Greg Edwards

This spider web, a personal picture by Jay Maisel, shown above, is unforgettable; it underscores his fascination with light.
© Jay Maisel

image reveals a nervous person under stress and not a genial executive. Of course, it's better to notice those things when you are taking the photograph than when you are making a selection from the finished images. But at the editing stage, you can at least try to pick a better version of the shot.

A FEW DOS AND DON'TS

Below are a few things to watch for when selecting your work for a portfolio. You may miss some of these points through carelessness or simply because you haven't given them enough thought.

Don'ts

- *Don't* take it for granted that you can use the pictures you shot for stock sales in your portfolio. Those images could be hot items in a stock file, but they may not be good enough for portfolio samples.
- *Don't* show pictures made for audiovisual use unless they are exceptional. These images are made to flash on a screen for only a fraction of a second and they are usually not required to be of the highest quality. The AV assignment usually calls for quantity rather than quality. The subjects may be fine and the action excellent, but if you look closely, you will often find that only a few of the images are of portfolio quality.
- *Don't* use second bests from outtakes unless they're really good. You may remember only what a smash hit the first-choice image was when you delivered it to the client. Don't automatically assume that when you go back into your file and pull out the second choice, it will be just as strong. Study it carefully. It may lack the same punch as the first choice or contain something slightly different that makes it second rate. In that event, it's better to ask the client to

let you make a good dupe of the first choice.

Dos

- *Do* insist on good color prints and faithfully duped transparencies from your lab. I advise you to become a virtual fanatic in returning to the lab copies that fail to do justice to your original transparencies. I realize that you can only complain to the extent of the quality you are paying for, and that you must know what can and what can't be done technically, but I have seen too many photographers pay top prices for poor work. Often they are simply unaware that the copies are inferior because they didn't insist on perfection.
- *Do* make sure that tearsheets are neatly trimmed. Avoid ragged edges.

Ask These Questions to Test Quality. For a start, ask these questions while judging the quality of your pictures.

What is the statement or idea? Is the picture making a clear statement? Is it easy to see an essential point coming through loud and clear?

Is it a fully realized image? Often a good hard look at a picture reveals that it is only a snapshot and not worthy of your consideration.

Does it convey a mood or feeling? Does the image move, enlighten, or stimulate me? Is it an image that, to again quote Cartier-Bresson, "gets under the skin?"

Have I rendered a fact or made an interpretation? Interpretation turns a record shot into a visual statement.

Is this one picture or really two? Sometimes you will find that the composition is poorly handled, or you weren't sure which of two ideas you really wanted to express.

Does the composition comfortably "lead my eye"? If not, is the image "jumpy"? Does your eye look here, there, and everywhere without centering on a point of interest?

HOW TO BE CERTAIN YOUR COLOR PRINTS ARE THE BEST YOU CAN GET

There is only one way to be certain that your color prints are of the highest quality possible. Take your original transparency in hand and go over it with the eye of an eagle. Compare it point by point, tonality by tonality, with the color print your lab turns out. You are apt to get some unexpected surprises. A bright, juicy green may turn out to be a slightly sickly yellow on the print. Or a soft red might become a bright red and clash with the delicate pink next to it. If you pay a good price for the print, you have a right to take it back to the printer. If he doesn't do a better job, then take it back once again.

Watch particularly for miniscule croppings at the top, sides, or bottom that weaken your composition or that eliminate tiny, though important, accents. Look also for unsatisfactory increases or decreases in contrast, blocked up shadows, or subtle changes in color relationships that can, when added up, lessen the quality of a print.

Similarly, make sure that duplicate slides and large transparencies are really faithful duplicates. Compare the dupes with your originals, searching for the same defects that you might find in color prints, including color shifts, increases or decreases in contrast, and miniscule cropping of the image.

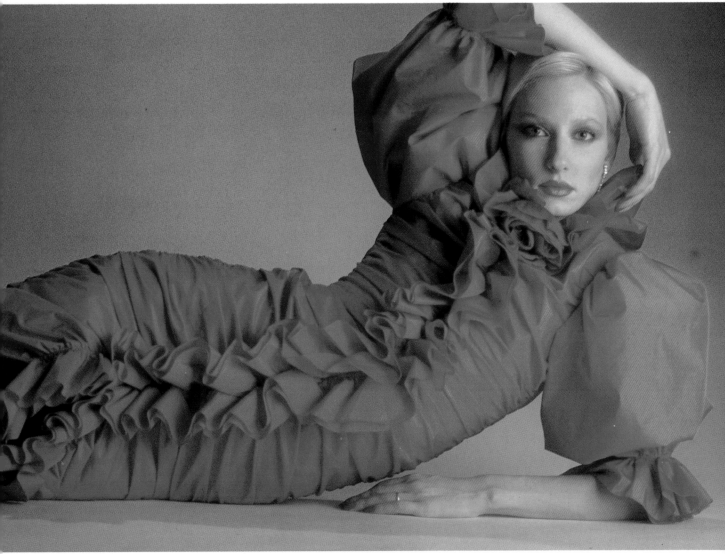

THIRD: CHOOSE YOUR MOST SALABLE PICTURES

So far, so good. You have accomplished a great deal in the preceding two parts of the process. You have taken your miscellaneous collection of pictures, sorted them into easily handled small groups according to their subject or style, and you have selected, roughly at this point, your best images. The third step in this method is to decide which of these pictures will do you the most good in sales and which are to get star billing.

Now is the time to stop editing for a few moments, stand back from your work, and *think*. Relax, maybe have a cup of coffee. Let some of the feelings and ideas that have been accumulating about the pictures you've been editing percolate through your brain. This is a tough job you are working on, and you need to take a breather and get a little distance from your work.

Be Clear on Your Aims. Think about your objectives for the portfolio. What markets do you want to reach primarily? Do you want to get more business of the kind you have been doing—or are you interested in seeking out a new type of market as well? What's salable for one purpose may not be the best choice to fulfill another. So it will pay you to think things through.

I never plan a portfolio without asking myself, "How will these pictures stack up with the clients they'll be shown to? Are they likely to influence the clients I'm aiming at?"

To refresh your perspective, you may find it helpful at this point to take a quick look at some of the earlier chapters in this book covering your direction, your clients, and your markets. Also very much to the point is Chapter Six: What You Show Is What You Get.

HOW TO EVALUATE SALES POTENTIAL

Here's the procedure I usually follow in evaluating the sales potential of pictures for a portfolio. I don't do it the same way every time or necessarily in this order.

Make a list. If you are going over many subjects and categories—and this often happens—I suggest that you write down all the titles of your groups. A list will aid you in checking for major themes and in spotting duplications.

Rate your subjects. Using a scale of one to five, grade each group and each individual image as you come to it, according to its sales potential. Ask these questions:

- How much work can I expect to get in this subject area—how much is the market using?
- Are the clients I intend to contact using this type of picture?
- Will this group of pictures add to the impression I'm trying to make?
- How much will the picture convey to a client about my specialties and abilities?

Bring related themes together. You may have certain subjects that fit into an "umbrella" category and would do well when placed together. This can help to streamline the portfolio. I've described this method in Chapter Eleven, on sorting out your pictures. Remember the differences I've cited between subjects and categories, and the example of how the specific subjects of automobiles, buses, trucks, and planes would fit very well into a broad category under the heading of "transportation." By physically assembling these related groups now, you may spot the major themes for your portfolio more easily.

Move pictures around. The subject groups that you want to see featured should be placed up front and the minor groups positioned toward the back. Play around with your groupings until they start to feel right.

NOW IS THE TIME
TO NARROW YOUR SELECTION

You have been eliminating pictures as you went along, but only loosely; I've suggested that your final culling should wait until you organize the portfolio. At this point it is well to do your next-to-last weeding down, remembering that you may need an extra image here or there to make a transition or fill out a theme.

Count your pictures now. Count them in two ways. One, count the total number, and two, count the number in each group. The total count will tell you approximately the number of pictures overall that you need to eliminate for the presentation you have in mind; the count in each group will tell you which is overloaded and how ruthless you may need to be in cutting it down.

Once you have completed this task, you're ready to start arranging your portfolio.

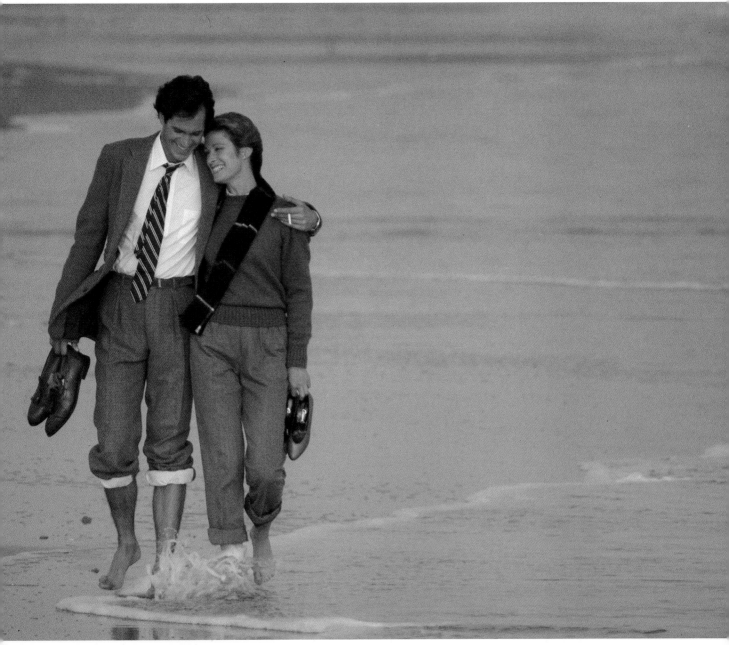

FOURTH: ARRANGING YOUR PORTFOLIO

If you have done the preliminary work of editing outlined in the last three chapters, you should by now be feeling a better sense of control over your material than you ever had before. The prospect of arranging your portfolio should now be much less intimidating—and very possibly give you a pleasant feeling of anticipation because you are well set for it.

We'll shortly be discussing some of the finer points of arranging your pictures, such as sequencing, making transitions, and pacing. But here I want to go into the general rules for the overall organization of your portfolio. First, as I've been emphasizing so strongly throughout this section on editing, it is essential to group your subjects together. This has been the key to every part of the process—sorting your pictures, picking the best and choosing those with the strongest sales potential. Now this principle is more vital than ever.

The Purpose of Your Portfolio is to Score Points. Every time you show an intelligently grouped set of pictures showing what you can do with a specific subject, you score a point for yourself in the mind (and memory) of your client. Art directors have specific accounts to deal with—whether wristwatches or insurance or plane travel; corporate designers have annual reports and brochures of various kinds to think about; magazine editors have a variety of subjects scheduled for each issue. When they look at your portfolio they think in terms of its possibilities for the work they either need now or will need before long.

Don't dilute your point. Whatever you want to emphasize, play it up strongly. If one of your strengths is the testimonial type of head shot or executive portrait, for example don't sabotage yourself by showing only one picture and then fol-

lowing it with something else. Show several of the best images of each kind together.

START STRONG, END STRONG

In arranging your portfolio try the trick the old vaudeville actors used so effectively: Start your act strong and end with a blast that will leave your audience wanting more. Clients, like everyone else, react to first impressions. If they are impressed by the first few pictures you show, they are apt to be predisposed to react favorably to what follows. And do you remember the old saying, "Always leave them laughing"? With your portfolio, it's a case of "always leave them impressed."

• **Sensational Openers.** Show half a dozen or so of your real "show stoppers." In this way you immediately tell your client that your portfolio is worth paying attention to, and you set the tone for what follows.

 It is a good idea to use opening shots that all belong to the same subject and which are part of a major subject area in which you want to generate business. If you don't have enough smashing images on one such subject, however, you can always use half a dozen different subjects, providing that each is a real stopper and that they all work well together.

• **The Middle.** It's all right to drop down a little in impact after your strong opening, but be sure to pick up the power again in the middle with some of your strongest pictures, so that you don't lose your audience's interest.

• **Powerful Ending.** Try to end with half a dozen of your most powerful pictures to leave a lasting impression. These last few images should be as moving and memorable as any you can find.

 You have several choices for your

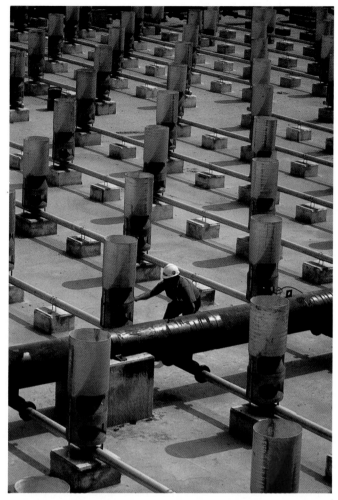

ending. One is to do a reprise of your strongest subject, perhaps using some of the pictures that were too numerous to be used in their earlier grouping. I realize that this means repeating a subject and some people object to this. If I do it, I try to select those images that reveal a different angle of the subject. For a rough example, daytime scenes to begin with, night scenes later. Another way is to show, again, a miscellany. The third is to end with a new subject untouched earlier in the portfolio—but only if it is very strong.

- **Better Safe than Sorry.** Beginning photographers, especially, may lack a sufficient number of outstanding images to use this formula. If you lack stoppers, try using just plain *good* pictures on a "safe" or universally usable subject. Think of one type of picture that *most of your clients are currently using.* For instance, in my experience, most clients—whether advertising, corporate

or editorial—use what I call testimonial type or "talking" pictures of people looking into the camera and saying something. These are head or torso photographs of people expressing an emotion or opinion, and this is always a safe group to use to start your portfolio. An example of this type of picture would be an individual saying, "I'm glad I bought XYZ insurance before my house burned down."

SOME GENERAL POINTERS ON STRUCTURING THE PORTFOLIO

Here are a few things to remember when you put your portfolio together. Some of these I've mentioned before, but they are worth repeating.

Highlight Your Major Subject. Structure the portfolio so that your most important subject comes first and is given the most attention.

The less important phases of work—

These two photographs by William Rivelli complement each other in color tonalities so well that the two together are stronger than either would be alone (although each is excellent in itself).
© William Rivelli

Tim Olive's portfolio consists of 2¼" × 2¼" color transparencies handsomely mounted in black mats. Note, he uses a combination of ad reproductions and original color. One reason this presentation works so well is that he groups his subjects on each page. Here you see product shots on one page and people pictures on the other.
© Tim Olive

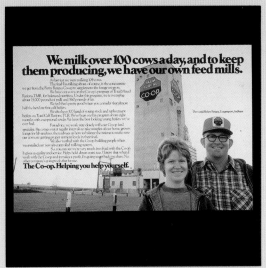

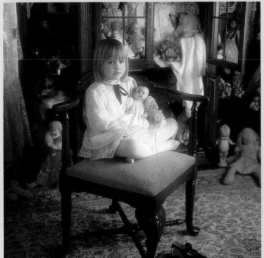

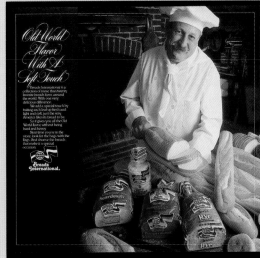

the minor subjects—can be worked in between your primary samples. It all depends on your material so I can't be more specific here.

Treat Style as a Subject. Remember that you can, if you wish, feature as a separate group those pictures showing a particular style or technique.

Leave Room for a Miscellaneous Group. Almost always you will have a few pictures that don't fit into any grouping—either you have only one of a kind, or it covers an unusual subject—but the images are so fine you ought to show them. I recommend making a separate little group of such pictures and working them into your portfolio. By making such a group you avoid just dropping a single picture here and there into your lineup and thus hurting the flow of your presentation.

Use a Few Personal Images. Many clients tell me they like to see a few personal pictures that tell them how a photographer thinks, and what his or her private vision is. This is particularly true with corporate and editorial clients.

Personal pictures can be anything from a magnificent sunset to a new way of photographing a red rose, from a futuristic sci-fi image to a splendid still life. A few superb landscapes in a corporate portfolio may tell a client how you might use background to dramatize an otherwise dull picture. For example, a few great sunsets I once included in a corporate portfolio brought a highly profitable and unexpected assignment. A year after I showed the portfolio, a client telephoned and asked the photographer to shoot an oil rig near New Orleans for an annual report wraparound cover. "The rig is in a dismal-looking swamp with no hills, trees, or even bushes to make it visual," said the client. "If he shoots sunsets so beautifully, he can make this picture work."

Avoid Mixing Black-and-White with Color When Possible. This is because we see black-and-white and color differently, and one may detract from the other. If you must use both in a tray, try to run your color first; then show the black-and-white. In a book with acetate sleeves, don't use color and black-and-white on facing pages (unless you have a special reason, such as showing two ads from the same campaign—even then I'd try to avoid it if possible).

A Narrative Sequence Need Not Be Chronological. Your strongest shot may be the one that shows something dramatic happening halfway through the story. In such a case, don't worry about chronology. By all means use the strongest picture as your lead.

Here's a true story about a photographer who got one of the earliest inside picture coverages on the Irish Republican Army for a magazine. He had access to the top levels of the IRA, and he returned to the United States with some sensational pictures of a raid—explosions, smoke, fire, people running, and men hiding from British soldiers. But the portfolio he showed had no dramatic impact because it was organized chronologically. It started with the much duller shots of the meetings in which the raids were planned, and the more spectacular bombing shots were submerged in the middle. When we rearranged the pictures, the set came to life. No truth was lost by forgetting chronological order.

When in Doubt, Leave It Out. Many an otherwise good portfolio is seriously weakened because the photographer "can't bear to leave out a single picture." Every time you leave out a doubtful picture, the impact of those you leave in is multiplied not just arithmetically but geometrically—truly.

When you have made your point, stop! Don't go for overkill just to show how good you are on a given subject. If you show too few pictures, you may not make your point; but, if you use too many pictures, you will lose your audience. Usually, two or three pictures will do it, depending on the material. But remember, as a travel photographer once pointed out, "How many African sunsets do you need to prove that you can shoot great African sunsets?"

The sequencing of pictures lends strength to your work. Notice how photographer Sepp Seitz's photographs are organized here.
© Sepp Seitz/Woodfin Camp Associates

Examples of good "stopper" images—your most striking images—to make a strong beginning for a corporate portfolio.
© Gary Gladstone

A memorable image of jet planes, like this one, facing page, is perfect for the start of any portfolio. © Al Satterwhite

The unusual image of mother and child, on the facing page, shows a masterful sense of design. It will attract attention by itself in an advertising portfolio, or with a group of mother and baby pictures, or with other pictures, dissimilar in subject, but related visually.
© Ken Ambrose

Self-discipline is needed, not ego.
Whenever you get so enamored of an
image that you can't bear to part with it,
do remind yourself that your portfolio is
serious business, not a scrap book. I
sometimes think we should all put a sign
above our editing counters: FORGET EMO-
TIONAL ATTACHMENTS TO PICTURES!"

IN A BOOK PORTFOLIO: THINK IN TERMS OF DOUBLE SPREADS

As you proceed, try to think visually in
terms of *double spreads*, never single
pages. Make sure that left and right fac-
ing pages work well together. Don't ruin
the effect of one page by placing some-
thing distracting or conflicting on the op-
posite page.

The pictures in double spreads should
always relate to each other visually. The
ideal, however, is when they relate in
color, design, *and* theme. A double
spread of related pictures is a good way
of scoring a point about your work.

Effective
Composition, color, and mood all play a part in making this arrangement of Michael Melford's tree pictures compelling. Each image relates well to the one before and after.
© Michael Melford/ Wheeler Pictures

Less Effective
The difference is slight, but if you place a sheet of paper over the pictures shown above, you will see that in this less clearly thought-out arrangement, this series loses some of its poetic power and emotional tone.

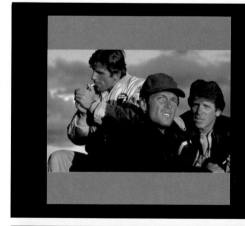

Effective
This little narrative series by Dick Durrance has a gripping quality in this arrangement, with an initial group closeup to engage the viewer's interest in its subjects. In addition, the second picture presents a more easily readable situation, and the other two follow naturally.
© Dick Durrance

Less Effective
Here the picture that the viewer can identify with most readily is placed last, and the series loses some of its force.

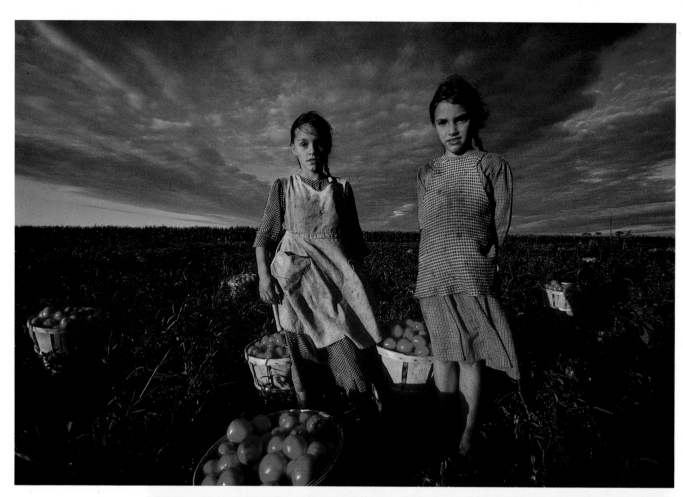

Either of these dramatic images could be "stoppers" at the beginning of a slide tray. Top: © Michael Melford/ Wheeler Pictures; Bottom: © Chuck Rogers

HOW TO HANDLE PROBLEM TEARSHEETS

Don't despair when some of your best pictures are spoiled in publication by a bad layout, or have been used so small they scarcely show up, or are buried in a brochure or annual report among pictures shot by other photographers.

When the layout detracts from your picture. If the picture is of a decent size—a size large enough to be worth showing—cut it out without a border, and use it by itself. Never mind if there's no logo or type to show it was published. If it's a good image, it will serve its purpose. Sometimes you can cut out the logo or headline and run it with the picture. Usually I don't much like to add logos because I feel it is the picture itself that is important; but outside the metropolitan centers, clients often like to see them. The other alternative, if the picture is a really good one, is to make a good print and use that.

When reproductions are too small. This can be maddening. You can't show an isolated 4 × 5 reproduction on a 14 × 17 page in a book or in a lamination. What can you do? Clip the picture and hold it until you find other pictures among your samples that have appeared similarly small and are on the same or a related subject. Then make a layout of your own.

You can usually manage to arrange the small pictures in a nice graphic layout—maybe three on an 11 × 14 background or, say, five on a larger page or lamination. Thus you will have accomplished your mission of grouping pictures according to subject and have rescued the little repros as well.

Don't use too many of such pages—not more than one or two—in your portfolio, or it will look spotty. But you can at least make use of some tearsheet materials with this method.

When only one or two of your pictures were used in an annual report. You can do one of several things:

1. Segment with clips or tape the pages that *don't* carry your pictures (to save the client's time in leafing through the report). Use attractive plastic clips or special tape. Then show the report.
2. Cut the photographs from the annual report and, depending on the size of the pictures, either place each of them alone on a page or make them part of your own layout, as described above.
3. Make prints from the images used in the report and show those.

When the client used the wrong picture. It hurts when you can't use a tearsheet from a prestigious client because it uses an image that you would have rejected. Instead, make a fine large print of your best image from that assignment and show that as your sample. But don't show it along with the tearsheet.

When the client mixed good and bad pictures. If the pictures are not too small, you can cut just the good images out of the tearsheet and make your own layout, as described above.

An example of a good way to make use of tearsheet pictures that were run too small in published form.
© Ross Lewis

125

When the reproduction is bad. Forget the tearsheet. Use a good print instead.

When tearsheets won't fit. What do you do with horizontal tearsheets that don't break well over the gutter in a book portfolio? My suggestion is to obtain several copies of the tearsheet so that you can cut and experiment. You can usually put two-thirds of the tearsheet on the left page and one-third on the right, or vice versa. Very rarely would you cut the tearsheet down the center.

To solve a special problem. Suppose you have been doing both editorial pictures and advertising production shots for a magazine that is one of your major clients. Now you want to move exclusively into advertising, but your page layout all have an overall candid, "grab shot" look. The effect of your other carefully propped and styled advertising images that are there in the tearsheets is lost when a client goes through your portfolio.

There is a way around this problem. A gifted West Coast photographer, for example, cut out the advertising-type illustrations from her tearsheets, created new layouts, and added some impressive new prints. With her new portfolio, she obtained her first big advertising campaign. She has been a successful advertising photographer ever since.

THE "CHEMISTRY" BETWEEN IMAGES

Pictures, like people, can strike sparks when they meet. They can be antagonistic or helpful to each other. If the "chemistry" is working, a weak picture can often pass unnoticed. In some cases I've seen, the second picture brings out a good quality in its weaker sister—a color value or a design—in the same way that a blue dress may intensify the color of a woman's eyes.

It's largely a matter of synergism, by which the combined force of the two pictures becomes greater than the sum of the two used separately. The more you are aware of picture chemistry, the more finely tuned your portfolio will become.

YOUR PORTFOLIO IS NEVER FINISHED

Don't let yourself get too precious about each and every placement or choice of picture. In my experience, there is a danger in too much fine tuning: It can have a homogenizing effect and your group of images can lose some of its force. There comes a point when you've done the best you can and must say to yourself, "That's it!" You can always rework the portfolio later, after you have shown your images to a few clients.

Let some time go by. If you can spare the time, let your portfolio sit for a few days. Your perspective will be fresher when you come back to it.

Get Clients' Reactions. Don't consider the portfolio finished until you have shown it to up to a dozen clients whose judgment you respect and have gotten some reactions. Don't take the opinion of just one person—or even two or three—allow for personal prejudices and blind spots. When I showed a portfolio as a rep, I not only listened, but I watched. I looked carefully during screenings to see where there was a nod of approval or where a client lingered over something—and I took note which pictures were passed over, sometimes every time, without interest. So be attentive to, and guided by, the clients' reactions; get a feeling for how the portfolio flows, which pictures seem to be winners, and which get the most comment and are looked at the longest. Keep shifting things in the portfolio until you know it is right.

Add New Samples as You Go Along. Every time you get a new sample—something prestigious, something that adds a new dimension, something important—incorporate it into your portfolio, while at the same time eliminating something less essential.

HOW EDITING SAVED A CAREER

The following example shows how proper portfolio editing helped a good photographer in the corporate field break out of a vicious circle. This photographer complained bitterly that he was getting only low paying jobs which required him to take so many pictures a day that he couldn't do decent work. He was considering leaving the field and going into audiovisual work. I went over his portfolio and found these weaknesses in his presentation:

1. He was showing too many pictures. Some were repetitive.

2. He was showing some pictures that weren't good enough, and he was showing some pictures that were irrelevent to his market.

3. The pictures that related to a specific subject or style were not grouped but scattered among other subjects, so he missed making a point.

4. The presentation was jumpy. It lacked transitions and sequencing that would have given it an easy flow. It didn't maintain the viewer's interest.

Here's what we did to change the portfolio and make it work better, using basically the same photographic material.

1. We left out some images that lacked quality, repeated points of interest already made with better pictures, or were irrelevant to the main thrust of the photographer's work.

2. We grouped together all the pictures relating to a certain subject or style, so that the client could quickly get the point of what the photographer did best.

3. We worked out a nice, easy flow of pictures so that the client's interest was bound to be held to the end. We worked hard on making fluid transitions, building up small sequences to prove particular points, and setting up a good pacing pattern that would prompt for new images before the old ones could get boring.

(P.S. When last heard from, the photographer was doing fine.)

MAKE YOUR PORTFOLIO FLOW: SEQUENCES, TRANSITIONS AND PACING

We all know that it is possible to show a portfolio of just thirty pictures and put an audience to sleep in the process, or to show a hundred pictures and leave people asking "Is that all?" The difference lies in the way the pictures are put together, or "paced," and good, fast pacing depends a good deal on how you handle the two elements of transitions and sequences. Too often transitions receive too little attention, with the result that portfolios move in such jumpy, disconnected fashion the viewer loses interest, or else they become monotonous without the variety and change of pace that sequences can add.

CREATING SEQUENCES

Sequences in a portfolio are a cluster of images linked by either a visual relationship or by an idea or subject, usually containing from two to four images, but in some cases a few more. Sequences can add an enormous amount of interest, color, and animation to your presentation. They also serve to break up a pace of pictures that might otherwise be monotonous. I have always found watching for and developing sequences to be one of the most creative parts of editing. Once you begin to open your mind to the possibilities, you will find many unexpected opportunities for sequences.

Many kinds of sequences. Photographers and teachers such as Ralph Gibson, Eric Hartman, and Ken Schlesinger have done valuable teaching on the theory of sequencing. Here, however, I want only to mention a few of the picture connections that can be found. Most sequences are based on one or more of these features: Relationships of subject or idea; Visual relationships including shape, size, color, tonality, and pattern; Similarity of mood, style, or technical treatment.

How to Find Sequences. You'll find most of your sequences while you are arranging the portfolio and actively thinking in terms of picture relationships; they'll also occur to you when you are choosing your best images.

Start with a pair. It isn't hard to find two pictures that relate to each other in one of the ways described above. For example: two balloons, two different city skylines, or two different but equally glorious mountains. Once you find a pair, you'll often find a third picture to go with it.

Start with an idea. Pick any theme that interests you as you glance through your pictures. It works this way: Suppose you see one of your images showing an attractive, lively elderly couple striding briskly along a beach, and you remember that this is the modern breed of active older people who are still enjoying life. A little later you may find another picture that fits into this theme—this time a handsome older couple dining in an elegant restaurant. If you put these two pictures together you will have created a sequence that not only tells a little story but makes a point about your perceptivity as well.

There is an infinite number of ideas you will come upon as you get used to thinking in terms of themes, depending on your own interests.

Juxtapose opposites. You need to be on guard against clichés, but putting together two pictures with diametrically opposed content sometimes makes a striking sequence. Think of the old Gothic architecture and the new glass towers; the teenager and the senior citizen; the elongated limousine and the tiny sports car; day and night scenes. Now take it from here.

One way to develop sequences is to start with an idea. Guy Gillette's photograph at left suggests a couple of ideas: a sequence of several equally fine portraits that will relate to each other in feeling and graphic treatment, or a series of testimonial-type portraits in which the subject may be making a statement of some kind.
© Guy Gillette

A sequence of temples and churches is interesting because it can show the variety of architecture and ornamentation in different areas, as well as the attitude toward religion.
© Kate Bader

Circular shapes provide a sequence to emphasize Gary Gladstone's use of design.
© Gary Gladstone

Group by personal style and technical treatments. If you've used an innovative, imaginative, or extremely personal style in a group of pictures, these might make a good sequence. Consider also unusual lighting, wide-angle shots, or any grouping of pictures showing special technical effects.

Create vignettes. I call these "storiettes." They consist of highly expressive detail shots, such as a row of people's feet under a table or on a bus; sensitive hands used in characteristic gestures; or a revealing series of facial expressions that, when put together, make a charming little miniseries and shows your imaginative talent and flair for observation.

Show three-of-a-kind or, *variations on a theme.* The first is a sequence consisting of three different treatments of the same picture. The second is three different pictures relating to the same subject. I particularly like showing three different treatments of one subject; it shows your versatility, imagination, and technical competence. For example, you could photograph a woodland scene in three ways: One might be in natural light, showing a gay, sunny mood; a second with a filter for a dark, brooding look; and finally, the scene shot with a wide-angle lens.

For variations on a theme you might use three different styles of modern architecture, or three beauty shots.

There is something magical about the number three. It seems to strike a spark every time.

Be Sure Sequence Ideas Work Visually. Don't make the mistake of confusing a sequence idea in your head with what actually shows in the photographs. Here is a typical example of such a mistake: A photographer showed me two pictures—a bullfight scene showing a matador swirling a cape at the bull and a wrestling scene showing two wrestlers lying on a mat locked in an arm-and-leg hold. "Together," said the photographer, "this sequence says *physical energy*." But did it? In the first image, the matador and bull are moving fast; in the second, the wrestlers might have been asleep, they were so static. Thus, no sequence.

In Action Sequences the Establishing Shot Comes First. Be sure to start an action sequence with the picture that sets the scene and explains what's happening, or you'll weaken the impact—or lose it entirely. For example, in a sequence about a fire, do show the burning building first and the firemen hosing it down second. (Here we're talking about portfolios; This rule might not hold if you were making a magazine layout, where you'd want a story-telling headline.)

CREATING TRANSITIONS

Transitions are the connective tissues that hold the pictures in your portfolio together. They make the passage from one group of pictures to another—as well as from one single image to another—smooth and easy for the client to follow. For any convincing presentation you have to lead your audience logically from one point to another. Transitions make that smooth movement possible.

A good transitional image will relate to both the image preceding it and the one following it. That relationship must be visual and it also must lead to the next idea in some way. Often the relationships provided by transitional im-

Above are shown three
memorable sequences:
At top, three charming
pictures of little girls, by
Nancy Brown; center,
three striking auto-
motive photographs by
Michael Melford; and
bottom, three dramatic
native drummers, also
by Michael Melford.
© Nancy Brown and
© Michael Melford/
Wheeler Pictures

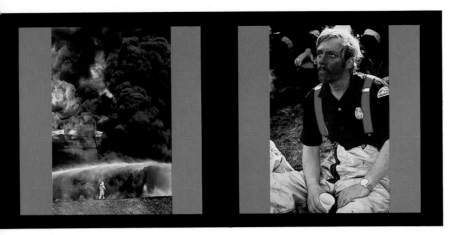

Transitions. In an action sequence it is important to place your establishing shot first. For example, in a sequence on a fire, the fire itself should come first. Visualize these two images with the fireman at the beginning; the effect is diluted and you only understand the sequence when you see the second shot.
© Ron Sherman

Here the establishing shot is the flower. This prepares the viewer for (a) another flower, or (b) another nature picture.
© Michael Melford/ Wheeler Pictures

ages, beyond the visual, are so subtle that you feel them more than you can verbalize them. For example, a picture of a farmer looking up into the sky, perhaps for signs of rain, might lead directly to an airplane flying in a wide expanse of sky. Here you have sky leading to sky, which connects the two different subjects visually; but also the farmer is looking up into the distance, so when we see the plane next, it feels right.

Good and Bad Transitions. Here are some tips on things to watch for.

Don't jump from long shots to close-ups. With drastic changes like that, you make your viewers shift their focus too quickly for comfort. Instead, bridge the two shots with a medium close-up in between. That's how we are accustomed to seeing things in real life—we start from afar and gradually come closer.

Move smoothly from outside to inside and vice versa. You can't always make the ideal transition, but it is helpful to try, especially in a slide presentation. For example, in a corporate slide tray, after an exterior view of a plant, don't move right into a close-up of a worker at a machine. The transition is too abrupt. Rather, if you can, show the plant's reception room and then a long shot of workers at machines.

Visual transitions in sports. If you wanted to switch from tennis to another sport, you could make a successful transition by showing a golfer in action. Both figures would be vertical, both would be stretching out their arms. But, to give you a less pleasing visual transition, suppose you followed your golfer with a swimmer in an indoor pool. The shapes would be different, and you might lose some of the effect because you would have gone from the open air to indoors.

Note: When arranging an advertising portfolio consisting only of a dozen or more pieces, transitions of this kind count less.

Transitions are Like Telling a Story. If you find the concept of transitions hard to practice, think of the verbal transitions you make when you tell a joke or story.

First you say, "We were in the house," and then, "we went outside," and then, "We walked in the park." You don't say, "We were in the house. We walked in the park." You use an intermediate, transitional sentence.

To tell a second story you make an easy transition with something like, "That reminds me of the time . . ." or "Did you hear the one about . . .?" These are all good, natural transitions. Remember them when you're making picture transitions.

Transitions are Time-consuming. I haven't yet found a way to work out transitions in a hurry. You try one thing—maybe it works, maybe it doesn't—and then you try something else. Sometimes I think, "We'll never finish with this portfolio," and then suddenly things fall into place and I wonder why I didn't see the right connections before.

Don't Try to be Perfect. There comes a time with every portfolio when you must be content with an abrupt transition here or there. You simply don't have the right pictures to make an easy bridge in every case. Don't waste time being overly precious. If you've hit it right most of the time, you're doing okay.

CREATING A WELL-PACED PORTFOLIO

What does it mean when people say a portfolio is "well paced"? They mean that it moves right along and holds one's attention from beginning to end.

Especially for slide shows. Good pacing is vital to every presentation but especially in slide shows. (That may be the understatement of the year.)

Pacing is rhythm. Think of how a musician shifts from slow to fast before a movement begins to be monotonous . . . how an editor varies the contents of a magazine . . . how a novelist moves from a descriptive passage to dialogue and then to action to maintain the readers' interest.

Observe how you pace your letters. We are all naturals at pacing. What do you do when you write a letter? First you talk about yourself, what you are doing, how you are feeling. Next you write, "But enough about me—what's happening with you?" Then you switch to news of mutual friends or gossip. That's perfect pacing.

How to Improve Your Pacing. Adding picture sequences to your portfolio and developing fluent transitions can really improve the pacing of your portfolio. The following are additional tips.

Watch out for weak spots. Try to put yourself in the place of a stranger looking at your portfolio. Is there a point at which the flow of your presentation flattens out? If you hold on to your objectivity, you can usually tell the moment at which the interest drops and a ho-hum feeling sets in. That's the time to stop, to try to figure out what is going wrong. It may be a result of any one of these faults.

• *Too many pictures on one subject.* It may be painful to eliminate some favorite images but don't hesitate to cut them when a series is too long. Brevity is better than boredom. You may be able to use those pictures elsewhere in the

The establishing shot. In action sequences, the establishing shot should be first. Visualize these two images reversed; the effect is diluted.
© Greg Edwards

portfolio. (You can always show them later in follow-up calls.)

- *A drop in quality.* Even one picture of poor quality can cause a falloff in interest. It is amazing how much damage a single weak image can do to the flow, like a wrong note in a song. So be vigilant.
- *A picture in the wrong place.* If you feel the momentum slowing but you can't figure out why, try this trick: *Go back to a point before the letdown began* and check whether a picture that doesn't really belong has intruded. Just one or two extraneous images can impede the flow of your presentation and allow the viewers' minds to wander.

Keep varying the pace. Don't stay too long with a run of distance shots or close-ups. After a number of long shots, bring in some medium-distance pictures. After using a few static scenes, put in some action. Vary color values also.

Change the perspective. How often have you seen a portfolio that contains good pictures but is unbearably boring? Often you can spot the fault: Every picture has been shot from the same perspective. To remedy this, use lenses of different focal lengths— a wide-angle here, a long lens there—and show pictures taken from a variety of vantage points. Shoot from high up, low on the ground, the left side, the right side, etc.

It's up to You. There is no exact equation for good pacing in your portfolio. It depends on the pictures you are working with. But there is one excellent rule. The legendary Swedish film director Ingmar Bergman says his first commandment is: "Always be interesting!"

THE UNEXPECTED BONUS: HOW BETTER EDITING IMPROVES YOUR PHOTOGRAPHY

It happens all the time. When you begin to edit pictures systematically you'll suddenly find the level of your photography rising as a result. This is how the change takes place.

Your "seeing eye" sharpens. By sorting your pictures in the way outlined in these chapters, you will be able to compare images minutely, and your eye will accustom itself to an awareness of every nuance of difference in pictures. You'll see details you never noticed before. This new keenness of observation carries over into the way you see a picture when you shoot.

Technical weaknesses show up. You may be making the same technical mistakes every time you photograph a certain subject or work with a particular kind of light, but you haven't realized—or have avoided realizing—that this is happening. When you do the detailed sorting and editing I recommend, deficiencies in your technique stare back at you so that you can't miss them. And seeing your technical problems is half the job of solving them.

You discover new facets of your talent. Many of us have an undeveloped flair for certain types of work that we don't exploit properly. Examples might be a gift for shooting humorous pictures or an unusual knack for getting a new look from old, familiar landmarks (which could prove profitable in a travel portfolio).

Take humor, for example: In editing your work, you come to a humorous picture of a man trying on a suit in a tailor's shop. The tailor has a comical expression on his face as he talks to the customer's wife. You make a mental note about "humor" and continue editing. Soon, perhaps, you come to another amusing shot in a group of beach scenes. You now start a tentative new pile of slides entitled Humor, which may or may not develop further. You find a few more witty images and add them. Soon you have a viable new category of work.

You become aware of missing pictures. As you edit systematically, you see gaps in your material that weren't so obvious before.

Incidentally, this method of editing can be very helpful to young photographers working on assignments in the corporate or editorial fields. Sometimes a photographer works very hard to do an outstanding job but misses an important shot that weakens the coverage.

I once edited a personality profile on a retired movie star. The photographer had spent several long days on the story, but when we sorted the pictures and laid them out in groups, we discovered they added up to only one activity—the movie star going shopping. There were just too many shots showing the actor at his haberdasher's, at his jeweler's, or at a shoe store. There were not enough images of his personal life.

I recall helping to edit a travel story shot in Greece. The photographer came back with plenty of good pictures of villages, street scenes, monuments, festivals, and Greek people. But when I put the images covering each "situation" into piles and then laid them out in an order, I looked in vain for one dramatic establishing shot that would symbolize the essence of the country and say, "This is Greece."

Remember that in addition to helping you produce a first-rate portfolio, your meticulous editing will give you a better idea of how you work and will help you produce better quality images.

THE 20 QUESTIONS COMMONLY ASKED

Many of these queries have been answered in other places in this book. It seems worth while to repeat some of them here, plus others.

1. *More and more often I'm asked to leave my portfolio overnight, without seeing the client. Should I do so?*

Nobody likes this, but I'm afraid the practice is here to stay. Art directors are busier than ever before and there are more photographers requesting interviews. The fact is, a certain amount of business does result from leaving portfolios. Many art directors do look at them after hours, often in a group session. I recommend having duplicate portfolios made up so that you won't be delayed in making other calls. If you are dubious, I suggest you leave your portfolio a few times and decide for yourself whether you will or won't leave your book.

2. *After I do leave my portfolio, I am sometimes told to pick it up at the desk, with no word or comment from the client. This is frustrating. Is there anything I can do?*

You can try telephoning the client to ask about the reaction to your portfolio and what the possibilities are for you. If you cannot reach the client, you can sometimes ask the client's secretary to procure this information for you, after explaining—gracefully, rather than belligerently—that you are a professional photographer and do expect a certain professional courtesy. If you get no satisfaction, accept the situation as part of the game and seek other, more courteous clients.

3. *How important are tear sheets?*

In general, they are very imporant. Good tear sheets give you credibility. They give clients reassurance that you can do what you say you can. Some long-established photographers have so many tear sheets that they show nothing else. If, however, you are too new to have good tear sheets to show, you'll have to settle for a great collection of prints until you get, gradually, the tear sheets you need.

4. *Color is prevalent. Can a black-and-white portfolio succeed?*

There is no question but that you will make more money if you shoot both color and black-and-white. However, there is something of a renewed appreciation of black-and-white photographs occurring in all fields—advertising, corporate, and editorial. It applies to the finest of black-and-white pictures, with rich tonalities. If you are dedicated to black-and-white, shoot on a very high level, and are satisfied to make less money (and don't expect immediate success), I believe you can gradually make a name for yourself with enough clients to make it work.

5. *Should I put together a different portfolio for every client?*

The trend is to keep two kinds of portfolios already made up: a general portfolio showing various types of work and one or more specialized portfolios keyed to different markets. Then, when special requests come in or if photographers are going after a specific account, they make up a hand-tailored portfolio. You'll find fuller details in Chapter 7.

6. *Should I include a few personal pictures in my portfolio?*

Yes, if you are seeing corporate or editorial clients. They like to see these to get an idea of your point of view and what you really like to do. Portfolios for advertising presentation are apt to be too limited in number to allow for personal pictures. I'd hold these until I knew the client, and show them separately at a later time.

7. *How can I tell if a client means it when he says "I like your work"?*

There is no sure way. You begin to be able to tell as you gain experience. You can usually get a clue by watching reactions as clients go through your work:

whether they flip through it with only a glance or if there is a gleam of response. Note if they pause to think (as if considering possibilities) before they answer. If they mean it, they may ask relevant questions about you and your facilities and fees.

8. *What about slide trays? So many clients won't bother to let you project them.*

This is a difficult question. I get conflicting answers to it. Some photographers say they can't get clients to look at slide trays; others tell me they have no trouble at all. Slide trays are preferred by many corporate and editorial clients, as a whole. Many famous photographers—Pete Turner, Cheryl Rossum, Douglas Kirkland among them—show slide trays. For the above-mentioned two markets, they would be my preference.

9. *Is it too much to show both a tray and a "flat" portfolio—the latter being either a book or laminations? If I show both, can I repeat any picture?*

I believe in having both a tray and a flat portfolio. More often than not, you will show only one at a time, but there are clients who will be interested in seeing both. It is all right to repeat some pictures? Each presentation must carry its own weight—you can't have one weak and the other strong because the weak one will pull down the other—so you may need some repetition. But don't repeat so many pictures that the two forms duplicate each other.

10. *Can I mix black-and-white and color in a tray or book portfolio?*

It is preferable not to mix these if you can help it. We "see" color differently from black-and-white, and it can be distracting to jump from one to the other. If you want to use black-and-white slides, try to leave a few spaces and then show them. Better yet, use black-and-white samples in your book portfolio, or in brochures you carry along.

11. *Is it a good idea to reshoot advertising tearsheets and show them in slides or large mounted transparencies?*

This is an excellent way to show tear sheets. Many photographers are doing just that.

12. *In a slide tray, do you like to see the name of the photographer in the first slide?*

It's a matter of preference. I think it is a good idea if A, you have exceptional material and B, you use a beautifully-designed signature slide. This is important because it reflects your taste.

13. *Some debate continues about the relative desirability of showing original vs. duplicate color. What do you say?*

Since most photographers now need duplicate portfolios, duplicate transparencies are pretty well accepted. Not only that but you want to protect your originals. The key point is that dupes must be *good*, or they do you a disservice. It is possible today to make or have made fine duplicates.

14. *Does it help to use the client's logo when I cut out an illustration from an ad or article?*

I personally prefer to let the pictures speak for themselves but I know that photographers from outside the major photographic centers find that their clients are impressed by the names of nationally known magazines and advertisers. So this is up to you.

15. *What can I say when a client hands my book back and says not a word except "Thank you very much"?*

This is truly hard to deal with. I feel that as a professional who has taken the time and put in the effort to show your portfolio, the client owes you more than that. I suggest taking the book back very slowly, while at the same time asking something like: "Is there anything in this material that you think might have possibilites for you to use me on in the future?" (You'll think of other forms of the question.) This will at least provoke some kind of answer. If the client is hostile, though, no clever ploys will do much good, beyond a certain personal satisfaction.

16. *Should I show tear sheets of magazine articles written about myself or certificates of awards in my portfolio?*

No. The client wants only to see your work. This is not the place for bragging. I used to occasionally clip short paragraphs from complimentary articles and arrange them on a page to be xeroxed. I then placed this page in the back of a portfolio, or used it as part of a mailer. But this sort of thing requires great care and must be done on an individual basis.

17. *What should I show for a follow-up call?*

That depends on what you find out about the client's tastes, interests, and needs on your first visit. Usually it will be new pictures that may expand on a type of work shown previously and liked, or something new. You don't need to show a full portfolio on a follow-up call.

18. *How do I handle my portfolio when I want to add a new category of work? I am a still-life photographer. I want also to do people pictures.*

The best way is to produce a new and separate portfolio of people pictures. You may show this to a whole new range of clients (if you are in a major city such as New York) or you may show it to your regular clients with an introduction that will let them know this is an addition, and not a change, so you won't lose business.

19. *I have no difficulty in showing a slide tray, but often the room in which I screen is too light. What can I do?*

Move your projector very close to the wall, even if it's only a few inches away. The images projected may come out quite small, but you will get good color saturation. Every inch counts. Your other alternative is to take along a desk viewer.

20. *You've talked about the value of grouping pictures by subject or style in a portfolio, and then adding a group called "miscellaneous." Can you elaborate?*

In every collection of pictures, a few images will evade conventional classification as a salable subject, or maybe you will find just one of a kind and to throw it into the portfolio by itself would disturb the flow of your subjects. So at some point you use an obviously miscellaneous group. Here is a slightly different example that demonstrates the point: A long time ago Jay Maisel used a corporate portfolio like this: in a large attaché case-type box were a dozen sensational annual reports he had done—and also a dozen stunning 14×17 color prints of miscellaneous subjects showing pictures he liked, including a luscious red rose; a dusky African girl in shadow, with accent of a shiny earring; a mountain road with a small red car climbing toward the crest, done for an oil company campaign. These pictures demonstrated Maisel's sense of design, his authority with color, and his gift for getting a penetrating emotional "feeling" into whatever he touched.

WHAT TO DO AND SAY WHEN YOU SHOW YOUR PORTFOLIO

We'll assume that you have done your homework and arrive with some knowledge of what your client does, and his or her interests. Let us also assume that you carry with you a portfolio worth looking at. How can you conduct your interview with the client in a way that helps you get the most positive sales results?

CERTAIN TACTICS HELP

Although I insist that you do not need an aggressive sales personality in order to sell your work, it is nevertheless true that you can clinch more sales if you use certain tactics to advance your cause. The following are a few do's and don'ts that I found to be effective when I was a photographer's representative.

- *Don't talk much.* Real pros know this, but others sometimes make a mistake. Never do a running commentary on each picture. Talking will only distract and alienate a client. He or she wants to be left alone to look and think.

- *But speak up when you have something to say.* When there is something really special about a picture that will interest, inform, or entertain a client, you'll be correct to speak up. In showing a travel series, for example, if a client seems interested in a picture or you know it is an important shot, it would be all right to say: "That is the only picture ever taken of this particular iceberg." Or, if you are showing an editorial portfolio, you'd want to say a few words about some exciting circumstance: "The helicopter was 50 feet up, visibility was nil, and we had ten minutes to shoot." In an advertising portfolio, you can always point out a shot that won an art directors' club award or gained notable acclaim, or make some other comment of interest. Just don't interrupt too often.

- *Be a name dropper.* It is human nature to be impressed by famous names. The bigger the accounts you work for, the higher your prestige, as a rule. Even if you are well known and everybody knows your level—but especially if you are half-way along or just starting—it can pay to mention that you are doing a job (or have just completed one) for a major agency.

The trick here, though, is to be an "organic" name dropper. You drop a name only when you can do it in such a way that it fits naturally in the interview; when it is relevant to the pictures being viewed or to the conversation. For example, when I showed Pete Turner's portfolio early in the game, we included a striking double-page ad for Simca cars. It was very good for me to say, when that spread (we used a book portfolio at first) came up, "You know, Young & Rubicam sent Pete to Hong Kong for one day to shoot that picture." At that time a one-day assignment to a farflung place was a bigger deal than it is now, and the story did impress clients with Pete's importance.

If you put your mind to it, you will think of possibilities for name dropping; famous names, places, and events; major advertisers; unique assignments. Don't think they won't raise your stock.

- *Be ready to describe your work.* You may have little time in an interview to talk about your work, but if the occasion arises, you should be able to express in words what you would like the client to keep in mind about you. This may involve describing what you like to do best—people pictures, industrial, travel, your style and approach to fashion, or whatever. I've discussed ways to describe your work in Chapter 5. The lines will vary from "I specialize in still-life," to "I'm particularly interested in very contemporary treatments of portraiture," or something like "One of my strong points is working out abstract concepts and making them visual." You must be able to encapsulate what you want to say in very few words.

- *Quoting price.* Setting and negotiating a fee can be difficult until you have had a good deal of experience. One thing that's helpful is to try to maintain a relaxed attitude and to avoid tensing up, so that you can think and talk easily. Try to get your client to tell you the budget on a job. If you must quote a day rate or a picture fee, try to use two figures, going from a lower to a higher range, so that you have room to negotiate. "Depending on the job" or "depending on the complexities" are two of your most important phrases.

- *Don't make excuses for pictures.* To explain why you couldn't get a better shot than the picture in your portfolio, or to apologize for another client's poor choice of pictures that appear in a tearsheet, will only hurt your standing. If a sample isn't good, don't use it, even if it hurts to leave it out. Clients are never interested in excuses.

- *If you are just beginning.* Even if you have only a few published samples, don't let that make you nervous on sales calls. Show your prints and be perfectly candid; let the client know that you are beginning, and eager to build your career. If your original samples are good and your portfolio is well put together, you'll find clients who will be willing to help you along your way.

- *Try for a sale instead of a sales call.* You can't expect to walk away from a first interview with a job very often, but if you have paved the way for future work, you have been successful. An important aid to clinching sales is this: If the client shows any degree of interest in you, try to get him or her to think of you in terms of actual work. Let us say you see a layout for an ad, part of a campaign, on the wall. Note whether it uses your kind of photography. You can't always ask, but there are many times when you can enquire whether the campaign is tied up with one photographer or if there is a possibility for you. Again, if you are talking with a magazine editor, you can refer to certain types of illustrations in the current issue, or past issues, that you would like very much to have a chance at when they come up again. There are many variations to this approach. Remember, the more you can put yourself into your client's thinking in relation to actual jobs, the farther ahead you will be.

- *Pay compliments discreetly.* It won't hurt to flatter your client a bit, providing you mean it honestly. To do that, you need to be aware of what your client is doing and have a reasonably knowledgeable set of values on whatever you talk about. But no art director or designer will feel bad if you say "I really thought that last (ad, issue, annual report) was super," or "I think the graphics on that piece were exciting." Not only does the client feel good to be complimented, but he or she likes the idea that you are interested enough to observe what's going on—and your awareness of the quality factors works greatly in your favor.

- *Pay attention to assistants.* Photographers sometimes make a mistake by ignoring the client's assistant. It is a mistake because any day, this year or next, the assistant will become an art director or picture editor. This, of course, is in addition to being simply civilized in your approach to people.

- *Recapitulating some suggestions in earlier chapters.* Just to remind you:

 Empathize with your client. Show that your aim is to be helpful. Remember, a client is more interested in what you can do for him or her than in what you want for yourself.

 Watch clients' reactions to each sample in your portfolio. When something gets only a passing glance again and again as you show it, replace it with something stronger.

INDEX

Designed by Jay Anning
Production Manager: Ellen Greene
Photographic Research by Laurie Platt Winfrey